Why are Animals Funny?

Everyday Analysis from the
EDA Collective:

Volume 1

Why are Animals Funny?

Everyday Analysis from the
EDA Collective:

Volume 1

Created and Edited by

Alfie Bown & Daniel Bristow

Winchester, UK
Washington, USA

First published by Zero Books, 2014
Zero Books is an imprint of John Hunt Publishing Ltd., Laurel House, Station Approach,
Alresford, Hants, SO24 9JH, UK
office1@jhpbooks.net
www.johnhuntpublishing.com
www.zero-books.net

For distributor details and how to order please visit the 'Ordering' section on our website.

Text copyright: Alfie Bown and Daniel Bristow 2013

ISBN: 978 1 78279 392 2

A CIP catalogue record for this book is available from the British Library.

Design: Stuart Davies

Printed and bound by CPI Group (UK) Ltd, Croydon, CR0 4YY

We operate a distinctive and ethical publishing philosophy in all
areas of our business, from our global network of authors to
production and worldwide distribution.

CONTENTS

Acknowledgements

A number of people deserve special thanks for their contributions to the Everyday Analysis project. Firstly, we would like to thank all those who have contributed to this book and to the blog, not just for their work but for their enthusiasm for the project and their inspiring commitment to its cause. A very special thanks is due to the Centre for Vild Analyse, and especially Henrik Jøker Bjerre, who were an inspiration for the project, and who have supported us throughout. We would like to extend a special thanks also to Jo Rose and Lucy Burns, for help getting the original blog up and running, and to Harriet Hill-Payne, for giving us the platform of the *Mancunion*, and allowing us to reach a wider audience in the early days of the project, and to the *Huffington Post* for featuring our blog. We would also like to thank Jeremy Tambling, whose influence can be seen in these pages. The same is true of Mladen Dolar. And to Fiona Peters and Richard Stamp we owe much. We extend our gratitude to our students, whose enthusiasm and criticism has been invaluable in the development of the project. Finally, thanks especially to Zero books, and to all of our friends and families.

0. Introduction

What is Everyday Analysis?

Everyday Analysis, or EDA, is a collective project, based primarily in Manchester and London, that takes everyday objects, items, adverts, signs, art, music, and anything else, and offers analysis of them. Ultimately the project's aim is to demonstrate how everyday life is full of complexities and inconsistencies which insist on being read and re-read, and which have the capacity to challenge and change the way we think. Our project, beginning in January 2013, found its initial manifestations online at our blog,[1] and in a weekly column within the pages of the *Mancunion*, the country's largest University newspaper, and later as a featured blog at the *Huffington Post*. We regularly update our content with articles from a host of contributors from across the globe, and have been delighted to see our following grow steadily over the project's short lifespan.

The Everyday Analysis collective is relatively large, with currently around a dozen contributors from a variety of backgrounds, and many others who have been involved in various ways since the project began. The collective element of the project is important to us. We aim to assemble a variety of voices, a range of positions from which interpretations are offered and can be placed in conversation with each other. As the second part of our introduction explains in more detail, we want to avoid providing answers and explanations, and instead set out to open up discussions and conversations about things which often go un-interrogated. We hope that having no presiding authorial voice is part of our fidelity to this cause.

The opening of a collaborative work by Gilles Deleuze and Félix Guattari reads: 'the two of us wrote [...] together [and] since each of us was several, there was already quite a crowd.'[2]

We too aim to write from this crowd perspective, not tied to the restrictive idea of a single-subject, a single author whose views and text are without multiplicity. Instead, we aim to give a variety of readings, which speak to each other, free from the limitation of a single authorial intention.

As recounted in an anecdote told to us by the noted literary scholar P. N. Furbank, T.S. Eliot had once confronted E. M. Forster over his granting to D. H. Lawrence the title of 'the greatest imaginative novelist'. 'What do you mean by *greatest* and what do you mean by *novelist*?' Eliot had questioned, and Forster retorted: 'Mr Eliot is trying to catch me in his web, but sometimes I would rather be a fly than a spider.'[3] Often, it seems, one has to commit, to risk one's reading and one's view, even if it means being caught. The articles in this volume are commitments to particular readings, but they are also committed to their own provisionality, to the need for continued discussion and debate. F. R. Leavis once remarked that the ideal critical assertion is: 'This is so, is it not? – Yes, but...' The articles here make a gesture not unlike this one in their attempts to open up further reflection and debate, and as a collective we hope that these discussions are just beginning, and that they encourage more analyses of the everyday to arise.

From smartphones to the 2010 UK general election, from toasties to Margaret Thatcher, from current affairs to music and film, all sorts of subjects are covered in our short and to-the-point articles, which aim to expose some of the awkward underpinnings of events and phenomena that might otherwise get simply explained away through a populism-courting 'common sense' that rebrands our discontent and detriment, and resells it to us as our recommended daily allowance (another aim has been to reintroduce a certain mode of aesthetic cultural criticism that has been lacking in mainstream media hegemonies...). Such ideological falsification and obfuscation is what we oppose. In this we might situate our project as following in the footsteps of

that of Roland Barthes' in his *Mythologies*,[4] which did much the same for the *everyday* of French life in the 1950s; or in those of the Slovenian philosopher Slavoj Žižek, whose forays into analysis of popular culture – from the *gaze* of the films of David Lynch to the *objet petit a* of Coca-Cola – have inspired a generation to turn to that exciting but ambiguous bunch of texts known as "theory", a *defence* of which will make up the second half of this introduction. We therefore pitch our mode of analysis as that *'other kind of discourse'* to which Zero Books are committed; that which is found in the interstice between points at which both the media and academia stagnate, and wherein we might be able to locate a certain *praxis* itself: that practical moment of *changing minds*.[5]

In his *L'Œuvre claire*, Jean-Claude Milner defines *'thought'* as 'something whose existence imposes on those who haven't thought it.'[6] This definition can be transposed to the workings of Everyday Analysis, especially in its relation to theory. Indeed, as with all critical practice worth the name, it is not a matter of grafting theory onto the everyday, but rather of realising its manifestation therein, of detecting how it comes about within and from the everyday; how it *imposes* itself out of this groundswell. Through our everyday analyses we aim to occasionally unearth some of the deep philosophical, ontological, epistemological, phenomenological, sociological, semiotic – in a word, if we must, *theoretical* – consequences of what may not be paid attention to in this way otherwise: the day-to-day, steeped in all its 'interpassive stupor'.[7] We can therefore construe Everyday Analysis as a defence of bringing the *everyday* – culture, advertising, spin-doctoring, memes, tweets, art, the popular and the avant-garde – into this realm of "theory", and we must also construe Everyday Analysis *as a defence of "theory" itself.*

A Defence of "Theory"

We'd now like to continue this introduction in something of the spirit of Sir Philip Sidney and Percy Bysshe Shelley, who both composed *Defences of Poetry*. Their texts thus set a mark for the articles in this book, and for this, its introduction; and we will set out by attempting to do something similar for "theory" as Sidney and Shelley have done for poetry; this, by following their *Defences'* amalgam styles of part-apologia, part-manifesto.

"Theory" – it is put in what get called 'scare-quotes' because we must begin by attempting to define it, and in doing so, to disambiguate it from certain associations and assumptions. Generally, the word encompasses – or tries to – a huge body of works (as heterogeneous in their unification as one would be led to believe when witnessing the desperate attempts at homogenising them being made today). A body, therefore, still very much compartmentalisable into categories of all sorts of disciplines – philosophy, cultural studies, sociology, literary studies, psychoanalysis, anthropology, etc. – and which, in times of auld, found such labels as 'the human sciences.' But the lumping all together of these discourses into this one scary word – by scaremongers scared of it and its possibilities – reverses an old adage and makes us wary of a policy of '*unite* and rule'; uniting disparate, and possibly dangerous, discourses, so as to dismiss them in one fell swoop, to rule over them as they're quarantined as "theory" (a demonstration of this *unite and rule* policy might be found, for example, in a recent tweet by Richard Dawkins: 'by "Theory"', he asks, 'you mean Theoretical Physics? Theoretical Biology, perhaps? No, I thought not. Pretentious crap again'...[8]).

Of course these highlighted discourses – those that have been subsumed into this amorphous idea of "theory" – are ones that have always interacted, often actively, sometimes radically and revolutionarily, with what they've read, critiqued, commented

4

upon, and come out of, and, indeed, this in all sorts of permuta-
tions of *power relation*. But in defence of theory against those who
want to divorce it from 'real life', from *the unexamined life*, we
might list such inextricable links as those between literary
criticism and literature itself; political philosophy and politics;
the tie between what we classify *culture* and cultural critique and
study. Against the charges of 'elitism' or 'academicism'
(whatever that really is) we might evoke *the very publication* of the
works we refer to as "theory"; i.e., their having been put into the
public sphere, into lending libraries, not jealously guarded in
some masonic cave, as is the idea we are sometimes given; we
might raise the point that the theory of psychoanalysts is *not* out
of bounds to any analysand, let alone to a general readership.
Against both these kinds of charge we may think of things as
disparate as *Marxism its very self*, or Scritti Politti's pop song,
'Jacques Derrida', Allen Ginsberg's being (amateur-)psycho-
analysed by William S. Burroughs, or hanging out with Félix
Guattari; a quick flick-through of whose *Schizoanalytic
Cartographies* will reveal a most "theoretical" – not to mention
creative – 'theorist' at work…

Nowadays (and perhaps always) it is indeed the case that in
certain quarters "theory" gets regarded as something that needs
to be shooed away – in its direct, confrontational *real*; i.e., in *its
own words* – something that needs to be shackled in its scare
quotes, locked in the very ivory tower it's often its intention to
knock down. It gets classified (and thus disqualified) as 'elitist'
or 'unreadable', or purely 'academic' (seemingly synonymising
this word with 'elitist', and thus – purposefully; politically,
perhaps – problematising academia along with theory…). But
isn't this form of disqualification in many ways one of libricide?
Is it really that theory *can't be read*, or does the proclamation of
unreadability often imply that it *shouldn't be read*? The words are,
after all, there in black on white. For the fullest response, which
highlights the covered-up true thinking behind these disqualifi-

cations, we refer the reader once again to Roland Barthes' *Mythologies,* and the article 'Blind and Dumb Criticism' therein.[9]

There are other types of critics of theory too: those who would call for theory's translation into a 'common tongue'; for it to be rendered 'understandable'... It may seem a reasonable enough plea immediately, but it is one that seemingly suggests that there is a destination to which all translation should aspire; something like a truly uncomplicated, uncomplicatable clarity. But one lesson theory teaches us is that language is a slippery and splintery thing in itself. This kind of *translation*, then, thus runs the risk not only of the dilution of concepts, but of their further slipping and splintering; and the demand for theory to be *made understandable* may well rather be a tool by which to *stand us,* as well as the theory itself, *under* those who make it; those who 'spontaneously assume the right' to deem understandability, and to prescribe it, to put it in the kind of phrasing Michel Foucault might employ.[10]

To offer up the "theory" itself, in quotation, and then our interpretation – which mostly is our method – seems to us also to offer the possibility of further interpretation; readers' own, of the theory itself, and of its interpretation(s). Thus, we should not, and cannot, come to regard theory *in the light,* say, *of Sokal and Bricmont* (a pair of physicists who famously dismissed most "theory" as 'fashionable nonsense' perpetrated by 'intellectual imposters'); it must be *embraced or rejected,* and we're firmly on the side of the former.

An important point here is that, as discussed above, "theory" really cannot be separated from what it reads – it is a process which is always going on, within us, and without. This is because "theory" is reading itself, which *produces* the thing which is 'read,' as well as getting produced *by* that thing. Theory is not the key to a text, it offers no 'answers,' it is not a tool to 'explain away' difficult material, but rather, it is *reading,* and a reading which is aware that reading produces both the reader and what

is read by that reader. Yet, often the reading and what's read are not in agreement but in antagonism; each 'resists' the other, continually displacing one another. This is in part what Everyday Analysis is about; the way also in which readings resist things, and things resist reading; that in everything there is tension and anachronism. In the everyday there are radical inconsistencies that should spur us into thinking, and reading, analytically and critically, and we defend theory as the inseparable tool by which we can inaugurate this mode of reading and of thought. As Žižek puts it: 'life without theory is gray, a flat stupid reality—it is only theory which makes it "green," truly alive, bringing out the complex underlying network of mediations and tensions which makes it move.'[11]

Whilst such abovementioned critiques and questions launched at theory – sometimes, indeed, in a semi-Socratic mode themselves – are necessary to keep it both on its toes and self-reflexive, it is in the lyrics of Gang of Four's 'Why Theory' that we can find a defence of theory itself and of the interpretation we try to lend herein; that of *everyday analysis*. Whilst *'each day seems like a natural fact'*, we must come to realise that it is *'what we think [that] changes how we act'*, and when *'too much thinking makes me ill'*, I still need to again when *'I think I'll have another gin'* … Welcome to the socio-politico-aesthetico-psychoanalytico-philosophico-diurnal world of Everyday Analysis.

1. The Email Sign-Off and Politeness

A recent article published in *Slate* magazine called for the end of perfunctory email sign-offs such as 'regards', 'best wishes' and 'yours sincerely.' For the writer, Matthew J. X. Malady, these gestures are 'are holdovers from a bygone era of letter writing' and waste time by causing email writers to agonize over the appropriate sign-off for the email they are sending.[12]

The UK newspaper the *Daily Mail* have, on the surface, and strangely for them, offered a review of the 'debate' without taking sides, simply offering the views for and against such politeness.[13] But close-reading nonetheless reveals the ideology behind their article. The writer has played up the 'fuss' that the *Slate* article caused. In keeping with their reactionary conservation of old models of politeness the *Mail* go as far as to begin with: 'A New York writer has sparked a debate about the manners of email after calling for an end to the written sign-off'; by framing it as a debate, their gesture is: 'don't worry, there are still plenty out there in avid support of the hierarchical structure of politeness.'

But is it really hierarchy, and deference to your seniors and elders, that the *Mail* wants to protect, or is there something else to the importance of politeness?

Theorist Robert Pfaller discusses how 'narcissistic societies' maintain a public sphere because they perceive any played role in it as an 'alienation' from the true self.[14] The statement is relevant here; the email sign-off, or the polite behaviour that the *Mail* wants to defend, allows the individual to believe that beneath this performance of politeness they have a 'true self' who could potentially act unconstrained by social rules and conventions.

Thus, the gesture that the *Mail* is making is not one of preserving an oppressive culture which does not allow you to 'be yourself', but rather it recognizes that one needs the exterior

public politeness in order to trick oneself into the comforting feeling of having a 'real' and 'true' self beneath that performance. The real beauty of politeness on the other hand, is that it is impossible to 'pretend' to be polite. If you perform polite, you are polite. In truth, there is no you behind your politeness.

2. On the Impossibility of Judging a Book by its Cover

Eve Arnold describes the scene in her famous photograph of Marilyn Monroe reading James Joyce's *Ulysses* on a playground roundabout: 'she kept *Ulysses* in her car and had been reading it for a long time. She said she loved the sound of it and would read it aloud to herself to try to make sense of it—but she found it hard going.'[15] Which is not at all bad going, as, when it comes to this notoriously difficult book, many would surely wish they could say as much.

But when it comes to Marilyn Monroe herself, and the peculiar breed of fandom her celebrity entails, there is often a tendency in her adorers to arduously try to reconstruct aspects of her life in as much detail as possible, often from the scantiest details of them available. The beholder of this photograph might indeed feel that 'irresistible compulsion' – as the German Jewish philosopher Walter Benjamin puts it in his 'Little History of Photography' – 'to search [the] picture for the tiny spark of contingency, the here and now, with which reality has, so to speak, seared through the image-character of the photograph, to find the inconspicuous place where, within the suchness [*Sosein*] of that long-past minute, the future nests still today—and so eloquently that we, looking back, may rediscover it.'[16]

But leaving aside any such speculations on Monroe's literary prowess, which, no doubt, has so often spoken for itself, we will rather concentrate on the phenomenon of two books in Joyce Studies appearing at the same time with the same cover. The occasions of the publications of Lee Spinks' *James Joyce: A Critical Guide* and Declan Kiberd's *Ulysses and Us* mightn't have been cause for much celebration to non-Joyceans, but the fact that they both have the same image as their cover does give a certain inflection to the old adage that advises us 'not to judge a book by

its cover.' They are very different works from very different approaches. What this photograph of Monroe on the front of both does though, is point to the power of the simulacrum: however well we know not to judge a book by its cover, our interest in both books may be initially piqued for the same reason of this very cover.

The photograph itself is thus exorbitant in this respect, but for what reason? Dialectically, we could say it's for this reason: that it embodies the old adage itself; that it stresses the impossibility of judging a book by its cover: whatever the most common preconceptions that go with Marilyn Monroe (the common tropes of bimboism and vacuous popular culture) and James Joyce (the charges of elitism and highbrow impenetrability) are, they are blasted from their continuities by this picture. As Declan Kiberd quotes in his book: ''a major work will establish a genre or abolish it,' said Walter Benjamin, 'and the perfect work will do both.''[17] In this instance of Joyce Studies, Eve Arnold's picture of Marilyn Monroe reading James Joyce in the playground has done just that.

3. Baby Food, or How to Eat Like an American: *An analysis of Man v. Food*

The television show *Man v. Food*, first screened in 2008, has become popular on both sides of the Atlantic, giving rise more recently to the programmes *Man v. Food Nation* and *Adam Richman's Best Sandwich in America*. The basic concept is simple: the host, Adam Richman, travels across the U.S. sampling the food of different cafés and restaurants, finishing each episode by attempting to complete a food challenge based around either quantity or spiciness (or both). Typical challenges include eating a 72 oz. steak and consuming 180 oysters in 60 minutes.

The show gives us an interesting insight into the infantilising effect of American food. The food included in the show is typically American: hot-dogs, burgers, chicken wings and pizzas feature heavily. This is food which is eaten from the hands, without knife and fork; it is messy, often impossible to consume without falling apart and covering the diner's hands and face. Such food returns us to an infantile state, allowing us to revel in a form of consumption which rejects social etiquette. The excessive nature of the food is part of this. The enormous burgers and steaks reactivate primal desires which are normally repressed: they promise to fulfil our desire in the same way as the breast holds out to the young child the possibility of re-unification with the (m)other to whom it seeks attachment.

According to Melanie Klein, though, the breast has two sides. The hungry infant divides it into the opposing forms of the 'good breast' and the 'bad breast'. The good breast is the breast that feeds us, offering fulfilment, while the bad breast is what emerges when the child expects to find the breast but doesn't. As a result, the breast comes to be conceived as monstrous, an enemy to be attacked and destroyed. This interplay between good breast and bad breast is revisited in every episode of *Man v.*

Food. The enormous meal, as the object of desire, stands in for the good breast, but it also appears before us as something monstrous which must be vanquished. This is why its consumption is staged as a contest. Every time the show concludes with either 'Man Wins' or 'Food Wins': either the breast has been subdued or it has rejected us. In this relationship, though, no result can be definitive; we are always compelled to repeat the drama again in the next episode and the next challenge.

4. Is God a Match for the Unconscious?

The idea of the ego has seeped far enough into our common discourse now for us to be aware of, if not its exact Freudian tuning, its approximate and accepted meaning. But what of the *superego*? Sounds like a superhero, and superpowers it does have, but unlike any caped crusader's; its power is to command, to *demand* – it is the unconscious centre of the demands made of, and on, a subject. Žižek often says of these demands, or *injunctions*, that they are 'obscene': obscene in that they can often be gratuitous, and even sometimes impossible. It may therefore rather be the villain that thwarts us than the hero that saves us.

Here is an impossible superego injunction: '*Find God's match for you!*', the tagline of the religious dating site, ChristianMingle, which is 'free to browse', before demanding payment for further usability. In searching through the eligibles here we might meet with a few difficulties. Firstly – knowing of the unconscious and its desires – we might be troubled by wondering whether our choice really accords with God's masterplan or whether it comes from somewhere else, somewhere within us, *more than ourselves*: *the kingdom of the unconscious*. Whilst this predicament begs the fighting question: *is God a match for the unconscious?*, our answer to it can be put back into dating terms; with the psychoanalyst, Jacques Lacan, we can say: *yes! a perfect match!* because, as he puts it, 'God *is* unconscious'; that is, *God is the superego*.

So if we really believe that whatever choice we make is made through guiding grace, the superego will take its vengeance. In his seminar on anxiety, Lacan reads the biblical commandment – to *Enjoy!* – as 'an origin of anxiety.' Why? When commanded to enjoy(!) by a higher – i.e., *super*, 'above' – power, *we have to obey*, but, as Lacan says, 'naturally I do not enjoy so easily for all that'.[18] So, whether it really is God's commandment or the superego's injunction – to enjoy – the function is the same; that of

the 'goads, and nails fastened by the masters of assemblies' in Ecclesiastes 12:11. Our anxiety is provoked by knowing that we *must enjoy,* but under supervision; *with someone above watching to make sure that we do!*

Knowing this should make us weigh up just *how free* we are to browse before clicking.

5. Is DJing a Resistance to the Standardised Commodity?

There's a status that goes with owning a record player and having a great record collection, just like there is with doing anything 'properly' or 'the old-fashioned way'. Owning a first edition of a book or a classic car is a statement, betraying our desire for 'authenticity' in a world that keeps churning out newer and newer things. When laptops started to replace CDJs, like any new technology it was met with resistance and hostility on the one hand; excitement on the other. Laptops avoid the trouble of carrying around CDs that can get scratched or lost, but you lose something here too: the physical pleasure of actually putting on a record… Loss is what technology tries to prevent but can't: we want the new, we purchase the new, but in doing so we automatically lose the old.

Technology aims to do more things for us all the time. 'Here's an electric toothbrush so you don't have to move your hand as much to brush your teeth'; 'here's something that means you don't have to bend down to wash your feet in the shower'. We're constantly convinced that the world is improving all the time. 'Gillette Fusion ProGlide razor is our most technologically advanced razor to date'…

The concept of progress through technology is critiqued most famously by Theodor Adorno and Max Horkheimer in *Dialectic of Enlightenment*. For them, history is not the history of progress, but the process of man's increasing enslavement to standardised technologies and commodities, concealed in a narrative of technological advancement.

So does the resistance to new technologies, even in an area like DJing – which is relatively new and technology-reliant – show us that despite the advertisements telling us to get the new this and the better that, we remain a little bit unconvinced?

Products are standardised: apples and socks all look the same, each physical album produced by an artist is exactly the same as the next one in format and often even in sound. But when you get out your decks, or whatever you use, you can take all the music you like and put it in whatever order you like, change the tempo, take out the bass, loop it; generally alter it.

Technology's insatiable desire to make everything easier, though, leads to innovations like the 'Synch' button, so you no longer have to manually match the tempos of different tracks. This level of standardisation is what some people resist, because it removes the human element from what we perceive as an art-form. Like the inevitable imperfections in the stitching of a hand-made throw, when you change the tempo manually on a CD track or on vinyl, you'll never get it perfectly in time. Those imperfections, though, provide a human, fallible aspect that makes the end product seem more 'real'. The resistance to ever-increasing standardisation and automation in technology, even in arts as new as DJing, shows us that even in popular culture – reliant on the newest technologies – there is a tangible resistance to the standardised commodity.

Still, to change the track, loop it, mix it and make it your own, you need to go out and buy the standard track, buy the laptop, buy the leads and the software. The desire to create something 'organic' and 'real' by yourself is catered for by companies who produce standardised technologies *that enable us to do this*. Some detest standardisation in music and culture so much that they desire to change it, but part of this resistance manifests itself in support of the culture industry, through the purchase of things that help us to feel like we're creating something new. If you're lucky, you could get really good at DJing, and have your mixes packaged up and sold as ready-made products themselves, so that the stuff you made your own re-enters the cycle of commodity production...

6. Old Spice and the Structure of Advertising

Walter Benjamin seems to hit the nail on the head, when he evokes the words of Roger Caillois, in comparing the advert to the detective novel:

> Nothing happens here that is not premeditated; nothing corresponds to appearances. Rather, each thing has been prepared for use at the right moment by the omnipotent hero who wields power over it.[19]

The item advertised seems to solve all your problems; it presents itself as that which will complete you. The Peugeot 206 will come with a perfect minimalist flat, a sharp suit, a high-paid job in the city and a model girlfriend. The box of Milk Tray will make you into an attractive sensual woman whose lounge is made entirely of velvet. And so on. Like the detective, the *product* will tie everything together.

And yet, it seems like something has changed since the days in which advertising worked like this. As the *'look at your man, now back to me/you're on a boat with the man your man could smell like/I'm on a horse'* Old Spice advert demonstrates, advertising knows this now; the advert has read Benjamin. The advert mocks the link between the product and identity; if you don't attach your identity to boats you will to oysters, shows, beaches or horses; if not to 'your man' as he is, you will to him smelling of Old Spice.

The temptation here is to say that the advert has a radical potential or something similar, that it can show us how our desires are structured. However, isn't it more that the structure of advertising has changed? Where before, in the days of *Madmen*, the advert was supposed to trick the purchaser into believing;

now, in the days of this advert, it plays another kind of trick, the trick of making it seem like the advert and the potential customer are on the same side. The advert is a kind of satire; it states: 'both me (the advert) and you (the viewer) are capable of standing outside culture and seeing how silly it is, that's how clever we are, now go and buy me anyway.'

7. The Centralizing Drive of 'Would You Rather...?'

Any university student will be familiar with the game 'Would You Rather...?' Initially a drinking-game, it's now so common that it's played out across text messages, in offices, and in school playgrounds on every day of the year. The game has become something of a cultural phenomenon; in 2012 it had a film named after it based on a game of 'Would You Rather' gone-wrong, and some websites boast having over 44000 'Would You Rather' questions to choose from.

In the game, players take turns to ask the other participants to select between two choices, and the appeal comes from what we learn about them as a result of their selection. The questions may have initially tended towards the sexual; what can we learn about our friends sexuality that may come out via their spontaneous answers. But questions can be anything at all. Some popular 'Would You Rather' questions online include, 'Would you rather have a part of your ear bitten off, or lose two front teeth?' and a quite remarkable find: 'Would you rather be a tree or a rock?' Completely uninteresting, these questions display an important desire that we have to see ourselves as centralized beings. Every answer I give is a symptom of some central 'me'; each answer refers back to an essence that I have, a part of which is revealed by my answer. Whether I would rather be a tree or a rock betrays some essential truth about me to my friends; I can only hope I give the right answer. Perhaps even I am unaware of this central me which is revealing itself, and I have to work through my own symptoms to figure out who I really am, just like the other players do. Alternatively, perhaps I enjoy taking part in the representation of this essential self to my friends via my answers.

In Sigmund Freud's *The Interpretation of Dreams* he introduces the idea of the 'navel,' which is 'a passage in even the most

thoroughly interpreted dream which has to be left obscure.' It is 'a tangle of dream-thoughts which cannot be unravelled'. Such a point is the dream's navel; 'the spot where it reaches down into the unknown'.[20] That which is at the centre, of the dream just as of us, is always deferred and inaccessible. Thus, whilst psycho-analysis recognizes the impossibility of getting back to the essential centre, instead seeing an infinite chain of displacements and condensations which reach back into an unknown and inaccessible origin, 'Would You Rather' depends upon the belief that this essential centre can be worked out and revealed.

But there is another pressure involved in the game. You must think of an interesting and/or funny question, or risk the judgement of your friends! Not only are your answers symptoms of your identity revealing itself, but so too are your questions. What will you think of? Can you be interesting and funny? In the world of 'Would You Rather' everything you do is a symptom betraying an aspect of your essential identity, and since you have no idea what that is, you must anxiously hope that you 'come out' okay in the game, that you give the right answers, and ask the right questions.

Whilst in psychoanalysis the answers you give and the questions you ask take part in the production of the subject who is speaking, 'Would You Rather' is bound to the idea of a centralized 'you' which is down there, and which every movement is a symptom of.

8. Celebrities on Canvas and the Birth of Photography

Increasingly common in art décor is a trend of turning photographs of famous 20th century figures into artistic canvas representations. If you *Google* the words 'canvas' and 'celebrity,' pages upon pages of companies will offer you such prints. These representations are massively appealing; they seem to offer something that the photograph is simply unable to. But what explains this move away from photography, towards what might even be thought of, despite taking its inspiration from contemporary art, as a retreat to an older form of representation, the image on canvas? Certainly the appeal is related to the less precise, less perfect representation of the individual that the canvas print offers compared to the photograph; the images are slightly blurred, less sharp, or even deliberately made to appear like drawings or paintings rather than photographs.

For Roland Barthes 'the photograph is a certificate of presence.'[21] Of course, this seems an obvious point; a photograph acts as a kind of proof, a guarantee that that thing in the photograph existed in exactly that way at that time and in that place. In a way that Facebook and Twitter make us increasingly familiar with, if you see a photograph of yourself that you have no memory of whatsoever, you still have to believe it. But Barthes' suggestion is that memory did not work in this way before photography began in the 1820s (the first photographs were taken by Nicéphore Niépce in this decade), that the effects of a new, accurate and authentic representation of identity is to change the way we remember our pasts; we now think of ourselves in a factual, linear way (think about how the family photo album, or the Facebook Timeline, combine linearity with photography). We also, and perhaps this is a more specifically modern phenomenon not relevant for 19th century photography,

feel that this linear narrative is out of our control, it somehow compiles itself, just as Facebook pages build themselves; your life is told, but you don't tell it.

And that sense of having your life told for you, a process everyone feels, is somehow epitomized by certain celebrity 'legends.' Having their lives written for them seems even to be a particular feature of the figures that commonly appear on these canvas prints: Michael Jackson, Tupac Shakur, Marilyn Monroe, Muhammad Ali, Bob Marley. These are all people whose lives have been imagined culturally, about whom we really know relatively little.

What these prints somehow offer is a way out of this narrativity, they have an appeal which is not connected to the life story of the individual, but which has something of the photographic language of 'capturing a moment' about it. Think of the famous images of Muhammad Ali, arms raised celebrating a victory, or Marilyn Monroe reading *Ulysses*, or Michael Jackson mid-performance.

But the work that *is done on* the photograph in this trend (each image is based on a single photo) is to remove the detail, to make it seem more vague, to blur the edges of the moment and the memory. The point that the print makes is that the moment is not experienced at its point in history. Often the background (the context) is removed leaving only the image of the celebrity; the now-blurred identity is transported out of its narrative moment. Indeed, all the images seem ageless, without their place in history. The point is that the moment is not experienced at its place in a narrative but only later on, when it is read and represented, when its significance as the 'moment' has been formed by later events. *This trend,* both literally and theoretically, could not have come before photography, because it responds to it, showing how the photograph's claim to represent the moment at its time in history is a false one.

Like when you realize that what you thought was a childhood

memory was in fact created by a photo on your parents' mantel-piece, *these canvases* draw your attention to the fact that when you look at the image, the moment represented is being created at that moment of looking, at the moment of reading and represen-tation, and not at its point in history when it actually 'happened.' What occurs in these, then, is something like the phenomenon Walter Benjamin describes of 'the historical materialist blast[ing] the epoch out of its reified "historical continuity"'.[22] The 'moment' is produced by a connection between the image and its recipient, and not in its place in a timeline of linear history.

9. You are What You are and What You are is OK: *The Truth of 'Fidosophy'*

The major injunctions of pop and self-help psychology are filled with antiphrasis: the statements 'Be yourself!' and 'Realise your potential' usually rely on the subtle sub-clause of: *'if you follow these ten easy steps'*... In his new dating show, *Gok's Style Secrets*, Gok Wan attempts to unlock women's 'potentials' – 'make them into themselves' – by suggesting changes in dress, dropping of habits, hobbies and idiosyncrasies, and the attainment of the societal status quo. And then there's the advertised diets that tell us all we need to do is think differently about food (the only takers for this advice, however, are likely to be those who are worrying about it too much already!).

The late work of Jacques Lacan tries something a bit different. That we must assume our lack we know already by this stage, but he tells us we must come to assume our symptom (or its *'Real'*, the *sinthome*) also. Or, as Žižek paraphrases it – in reformulating Freud's *Wo es war, soll Ich warden* – 'in the real of your symptom, you must recognize the ultimate support of your being'.[23] Symptoms are those bits of ourselves that psychoanalysis originally concerned itself with countering, if not eliminating (our making slips of the tongue that reveal things we don't want to reveal; our nervous tics that result from unconscious repression); but Lacan came to see some of these as things we have to live with – things that even make us what we are. To assume our symptom, therefore, is to realise that our very 'consistency' is to be found precisely in our '"pathological" singularity'.[24] Contrary to the populist ideologies, then, is this not what 7Up mascot Fido Dido's philosophy has been trying to tell us since the eighties? *'You are what you are and what you are is OK'*.

10. The Politics of 'Friend Zone'

A term originating in the American sitcom *Friends* has undertaken a new popularity in dating culture in the past few years. The 'friend zone' is the imagined space where a man (invariably) who does not initiate sexual contact with a female acquaintance within a certain timeframe is obliged to go. The phrase has a peculiar metaphorical loading. It assumes an idea of relationships as linear processes with various inevitable stop-off points. As the acquaintance between the prospective partners charges forward, failure to decisively redirect it along sexual lines will result in it reaching a point of development where it can no longer allow for sexuality. At the same time, the metaphor is topological, spatial. There is a specific place demarcated to hold the men who failed to act. Furthermore, whereas the poets of the twelfth-century courtly love tradition constructed their identity on the basis of an irrecoverable separation from the loved object, this iteration of the trope of unrequited love is slightly more complex. No mere separation, the friend zone is constituted by intimacy. The 'friend-zoned' man complains that he performs all the companionate functions of a lover, but without sexuality, in a kind of banishment-without-banishment. Friendship, in other words, is figured as a mutant version of sexual love: an impoverished parody retaining the architecture of the love-relationship but with the single reigning property removed.

The emergence of the verb 'to friend zone' – as in 'I took her out three times, then she totally friend-zoned me' – reveals another dimension of the term. It relates to what a number of feminists have pointed out is its misogyny: its tendency to be used as a corollary of the cliché that women don't like 'nice guys,' and are kept most keen by the 'assholes' who treat them mean. This starts by figuring the woman's ability to 'friend-zone' the man as a form of tyrannical arbitrary power, leaving men with

the choice between retaining their ingenuous niceness, or adopting more Machiavellian strategies in order to avoid the nice guy's dreadful fate. But the woman here is also a slave, attaching all her desire to that cruel master, the 'asshole.' What appears to be an elevation of the power of the woman in the first part of this formulation is obviously spurious. It is rather a violence against her, the violence of imposing *responsibility*, which in the philosopher Jacques Derrida's sense of the term means *the obligation to provide a response*.[25] The 'woman who friend-zones' is under obligation to provide a response to a male desire which, if the 'nice guy' himself is to be believed, has not even been articulated in the first place.

In *The Politics of Friendship*, Derrida considers Nietzsche's ostensibly sexist remark that a woman as 'a tyrant and a slave […] is not yet capable of true friendship: she knows only love.' For Nietzsche, friendship is destructively democratising, equalising. It means capitulating to the most heterogeneous disavowed recesses of oneself and of one's friend, and (in a move Derrida points out is unexpectedly reminiscent of the more radical edges of Christianity) assenting to the enemy within your friend: the part of him or her that scandalises everything you think you stand for. In contemplating friendship as a sorry substitute for love with a woman who is thought of as both tyrant and slave, the 'nice guy' has failed to grasp Nietzsche's point that such power-inflected thinking is incompatible with friendship. Whatever one can find in the 'friend zone,' one cannot find that. In Derrida's words, friendship means being 'generous enough [to] know how to give enough to the other. To attain to this infinite gift, failing which there is no friendship, one must know how to give to the enemy.'[26] Until he is generous enough to approach the woman not as a tyrant and slave, but in the true Nietzschean sense *as an enemy*, the nice guy would do well to remember Nietzsche's other solicitation (itself a rejoinder to the charge of his sexism): 'tell me, you men, which of you is yet capable of friendship?'

11. Love-Locks

Wikipedia nicely summarizes that Love-Locks are a custom by which padlocks are affixed to a fence, gate, bridge or similar public fixture by sweethearts at an increasing number of locations in the world to symbolize their everlasting love. The phenomenon is a new one, which began in the 2000s at the earliest. But what is behind this trend of symbolizing our love? Why do we do it? How does it work?

Does the lock, the image of being bound and chained, really symbolize how we feel about our loved one? Probably not, or at least we like to think not. So is it the public place we chain the lock to that contains the important symbolism? A traffic bridge over a dirty urban river? Probably not. Further, the 'everlasting love' element of the gesture is at least precarious; not only are the structures the locks are attached to often torn down, but the locks are often removed by authorities. In Florence 5500 locks were taken down by the council; in Dublin the council have committed themselves to removing all locks in the city centre; in Canada locks have been removed because they are 'a distraction from nature.'

So what makes us do it? The answer is: repetition. One lock means nothing at all, it does not contain any inherent symbolic quality that represents our 'true love' or anything like that. But when there are a whole load of locks, suddenly the symbolism starts to work. As such, Love-Locks teach us something funda-mental about relationships; the idea of relationships as 'unique' and individual is replaced by a sense of the repetitious quality of the relationship.

Aristotle made a distinction between two forms of repetition, *automaton* and *tyche*. Whilst the *automaton* is an automatic repetition, a machine-like, controlled doubling, *tyche* is an accidental repetition, a coincidence or chance meeting. The

automaton pertains to the repetition of the symbolic; a sign is a sign only insofar as it is repeatable, and this is what constitutes the symbolic. The symbolic is the idea of complete identity, the representation in language of something that appears to be outside language. This is exactly what is happening here, on the Love-Lock bridge. By millions and millions of repetitions of the same gesture, the impression is created that 'all these symbols must refer to something else, some powerful love or commitment which exists elsewhere.' In fact, there is nothing behind the repetition except our desire to believe that there is. As Søren Kierkegaard writes: 'the love of repetition is in truth the only happy love.'

Yet, on the other hand, the other form of repetition, the *tyche*, pertains to a completely different register. So whilst the first type is a repetition of the pleasure principle, a form of mastery and control (think of the lock) the second type is destructive and incoherent. But as Mladen Dolar has argued, these two forms of repetition are in fact always happening simultaneously. To put it simply, says Dolar, '*tyche* is the gap of the *automaton*.' There is a tiny gap between one occurrence and the next, which is difference itself. In every repetition there is, already, in a minimal way, the emergence of that which escapes symbolization. This difference is not the unique quality of our relationship with our boyfriends or girlfriends that makes it perfect and complete, but our inevitable failure in all attempts to symbolize the relationship as complete. It is not that language is inadequate to symbolize our relationship but that our relationship only exists within the inadequacy of language.

12. CrossCountry Trains: *How Can We Measure Ideology Today?*

John McCririck tells us in a special Cheltenham Cup CrossCountry Trains advertisement that when travelling with this company 'everything is laid on for you at your leisure!' The first comment on the YouTube video of the ad, from stevealston185, however, rather gives us these odds: '5-1 sit on the floor; 4-1 sit on the roof; 3-1 trolley can't get through; 2-1 aircon fails; Evens – DB, the German firm, want rid of this god awful franchise.' On the 15:11 service from Nottingham to Cardiff Central on Friday 15 February 2013 there were approximately 12-15 standing passengers to each vestibule, every seat being taken on the under-carriaged train.

One of the things Slavoj Žižek is big on identifying is 'precisely how ideology functions today.' Perhaps we can propose something of an empirical means of testing this functioning, in taking cognisance of the distance between an advertisement and its advertisand. If 'Everything laid on at your leisure' be the slogan, and sweatily standing in an unventilated vestibule with the trolley service waiting to get past for an hour the reality, here we can do something like attribute a simple ratio, e.g., 5:2. 5 for the 'five-star' expectation based on McCririck's slogan, and 2 for the actual experience (an overpriced journey in relative discomfort, which albeit got there on time).

Ideology, fittingly perhaps, is the colon that separates the ratio's two numbers; a colon giving enough leeway to allow companies access to unlimited disproportionate distantiation. In other words, there's no need any longer, on the ideological level, to represent a product's actual experience with a correlative expectation: there's no need for a monopolist to produce a true reflection of their product, to give its potential customers such real knowledge. Indeed, what other service can we use to get

home? And, nevertheless, it'll be full-whack again, farewise, to take the next sweaty train if we're pre-booked on this one. As Richard Appignanesi *et al* put it in *Introducing Postmodernism*: 'the opposite of knowledge is not ignorance but deceit and fraud'.[27] Ideology functions best today when the standing are in no way entitled to *take a stand*.

13. Hiding Racism in the Racist Joke

An Everyday Analysis reader encountered the following joke in a newsletter from a society that organizes social events for international students visiting Britain:

An Englishman, a Scotsman, an Irishman, a Welshman, a Latvian, a Turk, a German, an Indian, several Americans (including a southerner, a New Englander, and a Californian), an Argentinian, a Dane, an Australian, a Slovakian, an Egyptian, a Japanese, a Moroccan, a Frenchman, a New Zealander, a Spaniard, a Russian, a Guatemalan, a Colombian, a Pakistani, a Malaysian, a Croatian, a Uzbek, a Cypriot, a Pole, a Lithuanian, a Chinese, a Sri Lankan, a Lebanese, a Cayman Islander, a Ugandan, a Vietnamese, a Korean, a Uruguayan, a Czech, an Icelander, a Mexican, a Finn, a Honduran, a Panamanian, an Andorran, an Israeli, a Venezuelan, a Fijian, a Peruvian, an Estonian, a Brazilian, a Portuguese, a Liechtensteiner, a Mongolian, a Hungarian, a Canadian, a Moldovan, a Haitian, a Norfolk Islander, a Macedonian, a Bolivian, a Cook Islander, a Tajikistani, a Samoan, an Armenian, an Aruban, an Albanian, a Greenlander, a Micronesian, a Virgin Islander, a Georgian, a Bahamanian, a Belarusian, a Cuban, a Tongan, a Cambodian, a Qatari, an Azerbaijani, a Romanian, a Chilean, a Kyrgyzstani, a Jamaican, a Filipino, a Ukrainian, a Dutchman, a Taiwanese, an Ecuadorian, a Costa Rican, a Swede, a Bulgarian, a Serb, a Swiss, a Greek, a Belgian, a Singaporean, an Italian, a Norwegian and 47-53 Africans walk into a fine restaurant.

"I'm sorry," said the snooty maître d', "but you can't come in here without a Thai."

A few kinds of traditional form of joke are in play here:

'Englishman, Irishman, Scotsman,' 'X walks into a bar,' 'waiter waiter,' as well as that more generalised and resilient form: the ethnic joke. The humour, such as it is, comes from the fact that it initially seems like the old-fashioned racism we might anticipate from that kind of old-fashioned joke is going to be undercut by this absurdly long series of nationalities, only for it to come in at the end all the same. If those old jokes are dependent on there being a single identifiable "other" (the Irishman to the Englishman and Scotsman for instance), then how are so many nationalities, all with their own sense of who that 'other' is, going to provide a foil for such a punch-line? But after all that, the joke surprises by still managing to make a cheap pun at the expense of the Thai: here arbitrarily found to be funny because they sound like "tie."

There is probably some supplementary humour contributed by the idea of the snooty waiter looking for an excuse not to admit this suspiciously international and no-doubt noisy party, and this is what makes it seem like an appropriate joke for an international society. For one, it combines self-deprecation with self-congratulation ("look at us, always blundering into social situations where we are at best ambivalently received and under-stood! But we, after all, are the right-on progressive ones"). But more importantly, it seems to reveal all racial prejudice as the gesture of the waiter "looking for an excuse." Even in the face of a multiculturalism that has exposed all cultural values as relative, some bigots will seize on anything, however transpar-ently silly, as a reason to stand against the cosmopolitan future. Even, indeed, to the extent of making objections directly contrary to their aims, since we cannot imagine the maître d' being made any more happy by the addition of an actual "Thai" to the party...

But not all is at it seems. Who are the "47-53 Africans" that conclude the list of hopeful diners? The imprecise figure presumably corresponds to the ambiguous status of Africa's six

'island nations' in some accounts of the continent, and this version of the joke's wording no doubt predates South Sudan's independence, making it the 54th African state in 2011. In the telling, this, contracted to the joke's list of nationalities, is an inherent part of the comic tempo and probably gets a murmur of amusement in some circles. It allows the teller to make a self-aware gesture at the joke's absurd length, and creates a conspiratorial sense of relief between teller and audience that neither is going to have to sit through a list of another fifty nationalities. It is also slightly absurd in itself, combining as it does the oddly precise and haphazardly vague (surely it should be 47 *or* 53, unless only some of the island nations count?). The question that should make us uneasy, of course, is why, when every other nationality (and indeed two African nationalities, Egyptian and Moroccan) has been specifically named, should the other African countries with all their minute cultural specificities be summarised in this hasty way? And doesn't "47-52 Africans" have a touch of the old archetypal colonial ruler who thinks of Africa in that statistical way but considers it ungentlemanly to be too precise about having the figures to hand? The fact that the joke couldn't be as easily told with the concluding summary "… and fifty or so Europeans," even if this makes the same logical sense, flags up that this is, in however minor a way, racist.

The mock-racism against the Thai that establishes the joke's levelling anti-racist credentials comes, then, immediately after a statement of *actual* racism concerning "Africans". The punch-line which shows up the arbitrariness of racial prejudice by making a transparently ridiculous slur against a country with a comparatively small place in Britain's racial stereotyping, displaces a submerged but more serious jab at a whole continent with a very significant one. In short, the joke that adopts a pose of mock-racism to expose racism's absurdity is itself concealing within the machinery of its comic tone… its own racism.

The catachresis of this joke – the way it says more than it

means to say – has some address in the age of various incarna-
tions of mock-racism in popular comedy, ranging from Ricky
Gervais to Frankie Boyle. The familiar defence that this form of
comedy "doesn't mock subjugated groups, but satirises the
attitudes of those who want to mock them" is perhaps being a
little too definite about where its pleasure is located. The joke
that tries to subvert racism from inside racism's own language
does so only by disavowing the fact that much of the humorous
response it creates remains dependent on the old racist struc-
tures of humour. In other words, today, far from occupying a
post-racial utopia in which "we can laugh about it now": *I hide
my racism in a racist joke.*

14. Why the 2010 UK General Election Should Have Us in Stitches, but Doesn't...

When a Liberal Democrat told one of us that, 'what you don't understand about politics is this...', it seemed they were going a little against that policy of 'free debate' which is inherent in the party name, but it also got us to thinking: *what exactly is 'Liberal Democracy' in the grand political scheme of things*? In the political spectrum, we'll agree, there is the Left and Right, and if – as Slavoj Žižek argues in *Less Than Nothing*[28] – the Right *truly* see themselves as the preservers of a moderate and stable unified society and the Left as campaigners for greater social justice, then the Left can only be seen to the Right as intrusive and disruptive antagonisers, and the Right to the Left only as purveyors of a class-divide which keeps the advantaged at an advantage over the disadvantaged. But where do the Liberal Democrats figure in all this?

We would be acting too hastily to assign them the place of the 'middle-ground'. Perhaps it is more likely the case that the political spectrum is not actually riven by a middle-ground, but is instead '*sutured*', in the Lacanian sense: the Left to the Right. Suture, a concept elaborated by Jacques-Alain Miller,[29] is here seen as the process by which a stitch functions: in surgery, as in textiles, a stitch brings two lips of tissue together through their suture, and in the first instance is then most often removed, or dissolves, or falls away, and in the second is often hidden or covered up; for example, by a hem – in both cases leaving all but a trace. The *gap* between the two lips of tissue is thus only removed through their suture, and then the suture itself is removed.

In our above political analogy there is no middle-ground: the Left can only see the Right in a certain way and the Right can only see the Left in a certain way. This is so because the gap between

Left and Right is sutured, bringing the two poles together to form what we perceive as the political spectrum, and for this spectrum to begin operating the suture itself must dissolve, or fall away from the wound, leaving its scar tissue. That the political wound is neither open nor healed, but a scar, is the trace of its having been sutured. The suture, thus, *cannot speak for itself*, but rather confers a meaning on that which it has sutured *through its removal*. The meaning it leaves in the wake of the sewn-together Left and Right, for example, is that of the concept of politics itself. The stitch or thread cannot and does not take a political stance, but rather leaves a scar that is the political realm behind. This of course does not mean that suture is neutral; it cannot *even be neutral* as it cannot take a political standpoint at all, even that of neutrality; i.e., it cannot be neutral *precisely because it cannot take sides*: the stitch must dissolve entirely or fall away, not remain stuck on one side or the other.

The political spectrum is thus always already a coalition: the very result of its suture. In the true political spectrum the only thing that really binds the Left's thinking to the Right's is the fact that they are both *political*, in all else they are vehemently separated (this is the case even if in this country what is left of the 'Left' is only a tokenistic remnant; a fact which by no means compromises the concept of Leftism itself). Why then, are the Liberal Democrats not representatives of suture? The last election will provide an answer. Ideally, the Lib Dems would like to be *the suture that remains in place*. Remaining in place, however, is precisely suture's structural impossibility, and the 2010 election only goes to prove this in the fact that it forced the Lib Dems *to pick a side*.

For Lacan, the phallus is the master-signifier: like suture it confers signification, but it castrates itself in the process. For a brief moment Nick Clegg was the phallus *par excellence*. The most powerful politician in the country and yet bound by being only able to ask himself the one question: *who must we choose to render*

our party impotent? Precisely why the joke of our coalition government doesn't leave us in stitches is because stitches cannot be left in.

15. 'Newphoria' and the Case of the Mobile Phone

One can perhaps see this analysis coming; a criticism of popular culture's decorative mobile phone covers couched in a self-congratulating and highbrow language; that of Marxism. You say Swarovski crystals, we say commodity fetishism, you say retro cassette tape iPhone cover, we say... commodity fetishism. But no.

Isn't there something much more interesting to say about the idea of cases and covers? When we purchase a cover or case, we at least partly do so to protect our phone. But we overlook the repercussion; we have paid a large amount of money for the slimmest, smallest, most appealing phone (never shown in a case on the advert) and then we nullify this by making it bigger, bulkier and less-appealing, precisely in order to protect what we have paid for, even at its own cost.

Doesn't this show us something about the structure of our desires? It is not the 'slimness' that is advertised towards which our desire tends at all, but some invisible characteristic or presence within the product, some always illusive object of desire, which always remains unarticulated.

The new advert for Norton's phone and electronics protection, with the tagline 'if excitement over your new device is causing muscle cramps in your face you may have newphoria,' seems to capture all this perfectly. What we are looking to defend in our product is not one of its actual characteristics but instead some illusive 'newness' which produces happiness in us, but which we cannot approach or articulate.

Indeed, perhaps we can go so far as to say that the cover does serve a protective function. It protects us from the realization that our desire cannot be fulfilled; it maintains the illusion that underneath that big bulky leather case, and through that screen

cover and Manchester United/Hello Kitty back-cover, is an elusive, secret object of desire, which is my possession, and it makes me happy. If we actually faced the object directly, we would face the realization that it does nothing to fulfil us.

We need the cover precisely because it keeps the realization of our desires at a distance, since if our desires were to be realized, we wouldn't be able to handle it...

16. Tazreen Fashions Factory Photographs and their Reception

'Must we celebrate [death's] essence once more, and thus risk forgetting that there is still so much we can do to fight it?'[30] asks Roland Barthes in his essay from *Mythologies* entitled 'The Great Family of Man'. It would appear that a photograph that has been circulated on Facebook and Reddit, which has been reproduced by several (mostly American) media publications, would be doing just that. The photograph in question depicts two Bangladeshis, they look like a couple, who are depicted half-buried in the dust and rubble of the recent factory disaster, embracing in death. The photographer was Talisma Akhter who took the image obviously with much personal bravery.

This analysis deals instead with the way that this photograph has been viewed and disseminated in the West.

Nonetheless, I will not be reproducing this picture because its widespread circulation exposes many of the problems with our attitudes to disaster in the poorer nations of the world. While it's true that we are sometimes presented with photographs of the dead in the aftermath of disasters in the Western world, they are rarely described as 'hauntingly beautiful'.[31] Imagine photographs of a factory accident in, say, Ellesmere Port being described in the same way. The death of Others has become ours to aestheticise, and by turning this photograph into a work of art, we move towards celebrating death's essence rather than fighting it.

It will be objected though, that the circulation of this photograph is accompanied by appeals to help raise money for the victims of this disaster. It must be asked then why this particular image is used. Akhter speaks of bodies that 'were charred, like coal, or were only skeletons'.[32] These images cannot be aestheticised because, such is their horror, there is very little that is

recognisably human in them. Rather, in looking at the oppressed Other we select photographs that reinforce an 'ambiguous myth of the human 'community', which serves as an alibi to a large part of our humanism'.[33] We choose a photograph of a couple embracing in death, because love and death are 'facts of nature, universal facts'.[34] And, argues Barthes, this allows us to ignore the specific Historical context of the images, the socio-economic conditions that cause Bangladeshis to be treated as not human, as less than human. Hence the horror of the photograph becomes transfigured into safer terms, the romantic backstories of Reddit readers or even the photographer's own observation that 'the blood from the eyes of the man ran like a tear'.[35] We create a fiction for ourselves that these people are humans just like us, when so many of the clothes we wear are directly implicated in ensuring they are dehumanised in a way that we cannot imagine, whose image is much more akin to those charred skeletons. People are not human everywhere in the same way, because for millions of people, part of their experience of humanity is asserting that humanity in the face of forces that ceaselessly try to rob them of their humanity.

Barthes describes these narratives that appeal to a superficial identity between Westerners and those we oppress as preventing us 'by sentimentality from penetrating into this ulterior zone of human behaviour where historical alienation introduces some 'differences' which we shall here quite simply call 'injustices''.[36] By stressing these identities, when we make appeals for the victims of a factory disaster in Bangladesh, so often we are appealing for 'reform' in working conditions there, to make their working conditions a little bit more like ours (but not too much, else we will lose our cheap clothes). After all, is work not part of our essential human nature? Could that not be us embracing in that factory? I suspect that in making these equivalences, by making appeals with these sorts of images, we continue to perpetuate the global system of oppression. 'We know very well

that work is 'natural' just as long as it is 'profitable', and that in modifying the inevitability of profit, we shall perhaps one day modify the inevitability of labour'.[37] Ultimately the circulation of this photograph ensures the inevitability of profit, by hiding the dehumanisation of Bangladeshi labourers under the experience of universal tragedy. How much less likely for us to face the 'universal experience' of embracing our lover, locked into an overcrowded, collapsing factory.

17. Autocorrect in the History of Literature

A popular entertainment on the Internet is the 'autocorrect fail' compilation, capitalizing on the tendency of smart phones to automatically 'correct' otherwise innocuous text messages into absurd and often obscene nonsense. A graduate is directed to look for his college diploma in a box in his father's anus, chicken vaginas are craved instead of fajitas, and, in a text exchange between fans of a popular musical, the Phantom of the Opera 'is there… inside your mom.' As modern as this seems, the source of humour is a very old one. Shakespeare's hapless watchman, Dogberry in *Much Ado About Nothing*, routinely employs the same 'autocorrect' logic in his orders, seeking the most 'desertless' man to assist him as constable, comprehending auspicious persons (rather than apprehending suspicious ones), and condemning the play's villains to eternal redemption. The motif takes on a more specific class significance in the eighteenth century. Henry Fielding's novel *Joseph Andrews* shows Mrs Slipslop, an aristocrat's waiting woman, attempting and failing to distinguish herself from her fellow servants and mimic her betters with similar absurd substitutions. Another of the century's interfering older woman, Mrs Malaprop in R.B. Sheridan's play *The Rivals*, gives her name to this kind of linguistic mess up: her 'malapropisms' include reference to the smallness of her 'affluence' over her niece in the issue of getting her to 'illiterate' an inappropriate lover from her memory, in favour of another, described as 'the very pineapple of politeness.' The two people in the modern period to have given their names to the phenomenon of the wrong word are Sigmund Freud and George W. Bush. The 'Freudian slip' of the former occurs when the existence of similar sounding words presents a convenient escape route for the fact that we are anxious or undecided about

something as we are talking. More insidiously, as the philosopher Alenka Zupančič has pointed out, the ever-misun-derestimated President Bush was able to refashion his blundering 'Bushisms' – the Taliban having 'no disregard for human life', knowing 'how hard it is to put food on your family' – into the media-friendly pose of being a fallible 'ordinary guy.'[38]

'Comparisons,' as Dogberry says, are 'odorous,' but there is an important difference to be drawn between what we can call the age of the classical malapropism (from Shakespeare to Bush), and the radical development found in the autocorrect fail. The classical malapropism shows a rebellious tendency in language to struggle free and undermine us at precisely the moment we are asserting our authority. Whether we are meddling in our nieces' love lives or leading the war on terror, the fundamental hostility in language to any kind of secure total position is poised to hilariously undercut our self-asserting endeavours. From Shakespeare to Bush, the malapropism stands ready to scandalously reveal some hidden truth from behind our façade, whether of stupidity, social inferiority, or sexual anxiety. What distinguishes the autocorrect fail is that, now, this obviously can't be the case. We know the mistake is only the quirky result of a technology designed to intervene as often as possible for our convenience, which has happened to emerge at a time when, in text messages at least, spelling is probably more idiosyncratic and variable than it has been since the advent of print. Nevertheless, the reason the autocorrect fail is so funny is that, while we know that no personal shortcoming or repressed desire has really been exposed in these slips, it still feels like it has. It is as if the 'message' of our secret perverse sexuality, stupidity or whatever, arrives at its destination all the same. The desperate attempts at recovery in the text exchanges posted online – 'no mom I didn't mean...' – attest enough to that. The point that the autocorrect fail makes clear is that it was actually never just an individual failing that was being exposed in the classical

malapropism at all. If, as the linguist Ferdinand de Saussure famously has it, language is always a patched-together compromise in which no word is ever positively quite right, then a certain perverse mal-appropriateness inheres in all language from the start. There was never a space 'behind' language where improper material could temporarily hide itself. While from Shakespeare to Freud and beyond, the malapropism has always been attributed to special cases of hidden individual weakness, the autocorrect fail shows us that language is only ever founded on its own tendency to turn pinnacles into pineapples, dogs into dongs.

18. How Toasties Can Hide 'Little Bits of the Real'

In his work Adorno occasionally uses the word 'culinary' to designate something of an unanalytic and self-satisfied attitude, so cookery advice might be the last thing you'd expect from us, but...

There are three Lacanian orders (those put forward by the controversial psychoanalyst Jacques Lacan): the Imaginary, the Symbolic and the Real. To offer a quick crash course: if the Imaginary registers the split in subjectivity (the gap between what we know as ourselves and what we see in the mirror, for example), then the Real is that very split *itself*. The Symbolic is the realm of language and of knowledge, and the Real in relation to the Symbolic is as that which is unsymbolisable, inassimilable; all that which we cannot know, the magnitude of which can never be subsumed, let alone estimated. The Real is also that which breaks into our lives as trauma, the first symbolic impressions of which we repress and later articulate in symptoms. Lacan says the best we can ever perceive of the Real is only 'little bits'.[39]

Some, such as James Joyce, might welcome such 'little bits of the Real', and try their best to re-present them as 'real' (i.e., bring them into the Symbolic order), despite knowing the actual (Real) impossibility of such an endeavour; indeed, as he said of the compositional technique of his last major work, *Finnegans Wake*, in a self-critical moment: 'isn't it arbitrary to pretend to express the nocturnal life by means of conscious work?'[40]

Most of us, however, might prefer to dispel these 'little bits of the Real' from our Symbolic universe; and how better to do this than to seemingly convert them into symbolic entities? The following is thus of necessity a metaphor: but if we take a loaf of bread, and we don't want curly hair, we might be prone to

leaving and not eating the crusts, prone to – in a very small way – being slightly traumatised by there being crusts at all.

All we need is a toastie maker. Putting the filling on the crusty side and buttering the bread side of the crust, and laying this side against the hot-plate, then squashing the sandwich until it's sealed toasted, we'll get the end result of a toastie which looks and tastes like any other made of two middle slices, despite it containing *a little bit of the Real* inside. The efficacy of the toastie maker may then be a fitting metaphor for the efficacy of our own Symbolic orders...

19. Does it Really Make a Difference Whether it was James Gandolfini or Tony Soprano who Died?

'Death' seems to be the most common word applied to the natural. Even 'birth' is less broadly applicable to natural processes: a flower is not 'born,' the seed is planted and it grows. A fire is not 'born,' it is lit or it is started. But flowers die, flames die and people die. Whilst the other words change, death remains the same because it represents the completely unknown; it cannot be further qualified.

This prevalence of the word 'death' is strangely reflected in colloquial language: 'I went out to a bar but it was *dead*. Then my battery *died* so it was *dead* hard to get home. Now I'm hungover and I'm literally *dying.*' When we are bored we are *bored to death*; when we are hungry we are *starved to death*; when we love a kitten we *love it to death*. Here, it is the completely unknown element of the word which explains its popularity; it can take the completely mundane and make it into something extreme, so that it can appear to contain unknown intensity, something beyond us, something exciting.

How does the place of death in language relate to its position in popular culture? I'm sure you're *dying* to know.

Recent events have brought out the strange way in which when a famous person dies, there appears to be a competition to see who can post the first 'RIP' on their Facebook page and inspire a mild sensation of necromancy by mindlessly posting Youtube videos of the deceased. It always comes 'out of the blue,' and the social media frenzy is about being the first to break the news, to use it to shock others. If you aren't the first, you might be the first among your friends, or at least among some of them. Texts and status updates fly around, searching for someone who hasn't heard the news, so that it can be 'out of the blue' for them.

The death of the famous person is essentially fictional, one does not experience it personally, but it is a reminder that death is out there, striking at random into normality. Does it really make a difference whether it was James Gandolfini or Tony Soprano who died? No, we are only affected by the fact that death comes out of the blue.

Recently, President Obama gave a speech congratulating the re-establishment and maintenance of peace after the Troubles in Northern Ireland. The live broadcast was stopped *dead* in its tracks to bring us the 'Breaking News' that Prince Phillip was leaving hospital. The key point is not that the marasmus of an obsolete royal is more important than debates on war and peace, but that death must be kept as this unknown force from without, which radically interrupts the course of things, no matter how important that course may be.

Strangely opposed to this is the Nelson Mandela death countdown, on full swing on every news channel. Here death is not a shock interruption but an end to a long narrative. But Mandela is still alive and no one's used the word 'dying,' although journalists are keeping vigil outside the hospital repeating the fact that he's 94, and the people of South Africa are praying for him; which is 'a *dead* give-away.' When he does die, the word 'dead' will come in, so that it seems to be out of the blue, sudden, and unexpected, when we all know it isn't.

We celebrate famous and particularly unexpected deaths with heightened intensity because they perpetuate our fantasy that our own end will be an epic grand finale rather than a slow and unimpressive fading away. If we fade away we disappear, but if we go out in a blaze of glory we achieve semi-immortality; we will be remembered. We want to view our death as the most egregious event that will ever take place, in order to endlessly defer the great moment of our lives to the very end, to excuse or distract from the monotony of life, just as the word 'dead' does for us in colloquial language. To maintain this illusion, death

must be a thing of striking significance, both glamorous and surreal, not the slow and expected end to the narrative of life.

Glossing Freud, Peter Brooks explains that the 'death drive' tends towards sudden death at every point, but the 'pleasure principle' makes sure that we die in the 'right' way, completing the fulfilling narrative of life and ending with the closure of death.[41] But doesn't all this evidence of the way we treat death, as a concept and as a word, reverse this? Instead of seeking a linear narrative that ends in expected death, we want death to interrupt suddenly, as a glorified event from nowhere, breaking our narrative. We still see this death-event as providing the final completeness that we have been forced to defer, since we could not experience it in life. We still desire completeness and see the glorified death-event as providing it; but our concept of completeness has changed; we can no longer imagine what it might be, so it has to be sudden and unplanned.

20. 'Your a Dick': Richard Dawkins's Tweets

There is an amusing and puerile joke on Twitter. Whenever Richard Dawkins unleashes his increasingly unpleasant bile towards Muslims, any other religious believers, or, really, anyone who disagrees with him, people tend to respond with the words 'Your a dick'.[42] Interestingly, Dawkins calls these people 'illiterate', and puts a lot of store by grammar. His key demographic of nasty teenage boys, the sort who scoff at people for believing in 'the sky fairy', are just the type to shake off criticism by critiquing grammar, or ridiculing somebody who doesn't have the same God-like grasp of the rules as they do.

Nonetheless, this faith in the clarity of grammar is evidence that Dawkins's thinking is still theist in character, even if he rejects the usual narratives of God put forward by the major religions. To demonstrate this, I wish to turn to an atheist thinker of a completely different stripe to Dawkins, one who I hope will emerge more atheist than Dawkins in this short analysis, Friedrich Nietzsche.

I'd like to begin by stressing that Nietzsche is absolutely, unambiguously, an atheist. His most famous statement, that 'God is dead' would probably suffice enough, but since it is a far richer claim than it initially appears, I won't dwell on it here. Rather, I will turn to the Nietzsche I will be talking about later in this piece, in which he writes: 'concocting stories [*fabeln* – fables] about a world 'other' than this one is utterly senseless, unless we have within us a powerful instinct to slander, belittle, cast suspicion upon life: in which case we are *avenging* ourselves on life with the phantasmagoria of 'another', 'better' life'.[43] Nietzsche rejects any claims of heaven, of God, of a world to come, in favour of life as we live it, now.

In Dawkins's pronouncements about language though, this is precisely what he does. We find him claim, 'English is my native

language. My words mean what I intend. If you read them differently because of "social context" that's your problem.'[44] Who authenticates that one's words mean precisely in the way they were *intended*? Dawkins could claim that his words represent an intended meaning because social context has created generally-shared, but still ambiguous, meanings, on which he was drawing when he wrote the statement. However, he rejects meaning shaped by social context. Yet, if his meanings aren't created by social context, then what does he have to draw on? He may believe that his words mean precisely what he intends, using his own sense of them as a guarantor, but they can only mean if they are spoken or written and somebody interprets them, hence we return to the problem of social context. Furthermore, where did he derive these meanings if not from social context? When he says that English is his 'native language', he is giving his words authority precisely on the notion that, as a native speaker, he is better acquainted with the social context of his language. Dawkins though is sure that there is a guarantor of precise meaning, hence there must be another, Platonic, reality, above the spoken one, that guarantees the meanings of his words. If Dawkins believes only in life, what there is for us to experience, words must be made to mean by social context. Otherwise, if words mean, something outside of human beings, outside of social context, must make them mean. What is being concocted here is another world where words have perfect meanings outside of the shifting, unstable language of human beings.

This attitude to language is typical of Dawkins's unshakeable faith in the absolute power of reason. Could we forget that he is the founder of the 'Richard Dawkins Foundation for Reason and Science'? Of reason, Nietzsche writes that 'the prejudice [note the idea of pre-judging here] called 'reason' compels us to establish unity, identity, duration, substance, cause, materiality, Being – we see ourselves to a certain extent tangled up in error, *forced* into error; as sure as we are, on the basis of stringent checking,

that the error is here'.[45] That is to say, reason is itself a social context (Nietzsche mentions that this worship of reason occurs 'nowadays', it is historically situated), which guarantees our sense of our selves and the existence of the world we live in by leading us out of error. Yet who decides what is reason and what is error? What is this world that we are led to, out of this world of error? As in the case of language, it depends upon a world where concepts can be guaranteed by something outside the shifting, amorphous zone of things like social context, which lead us into error. For how can we know what reason is without recourse to the language in which we express reasonable things? Yet as Nietzsche points out, just as our eyes are incapable of determining what we see in astronomy for certain, so language too carries the potential for error.

This is of course not to say that science should be *dismissed* as just another construct of the social world, that these types of critique are claiming that science is invalid, as many paranoid scientists seem to think. Rather, it is about recognising that atheists like Dawkins, and his increasingly godlike pronouncements on the power of what he calls reason, in fact take a theist position, and create a world outside this one to aspire to. It attempts to make the world homogenous and strictured in a way reminiscent of lots of hardline beliefs of religion. True atheism then would be a new world of unreason, and would, we can hope, see our attitudes to the marginanlised radically altered in a way that reason has never been able to do in its three-hundred year history. And this is absolutely a matter of how we view language. As Nietzsche puts it, 'I am afraid we are not getting rid of God because we still believe in grammar...'[46]

21. Charity and the Disorganisation of Unemployees

Charity, as a cultural practice, keeps evolving. One example of what it increasingly looks like is Benetton's recent 'Unemployee of the Year' campaign. Last autumn, the Italian clothing retailer's Unhate Foundation offered to fund 100 'creative' projects proposed by unemployed young people around the world with €5000 each. In the accompanying poster campaign, various doleful-looking but attractive people pose in corporate attire, like 'Katerina, 30, non-manager from Greece', 'James, 23, non-sound engineer from the UK', 'Michaela, 29, non-photographer from Czech Republic'. The caption under each picture reads: '1 of the nearly 100 million people under 30 years of age in search of a job'.

What does this say about charity today? First, and most obviously, this kind of 'brand-aid' charity can barely disguise what is nearly always true: that in the first place, it helps the charitable. Benetton needs to flog multi-coloured knitwear, and their carefully constructed image as charitable-meets-controversial helps with that.

It is this 'controversial' aspect of the campaign that points towards a more general function of charity. If there is already something slightly unnerving in the perverted use of that corporate people-management tool, the 'employee of the year' badge, this is taken further in the campaign film, where in one shot mounted police threateningly guard unemployed protesters. For a moment the question is held out to the viewer what 100 million unemployed under-thirties might do if they got organised; of course, this possibility is quickly withdrawn with the call for entries for the charity project at the end of the film.

Here, the film and poster campaign inadvertently direct attention to an uncomfortable idea: that charity is about avoiding

conflict and preserving the status quo. The charitable give to the needy in order to prevent them from rebelling against social inequality in unpredictable and potentially threatening ways. Slavoj Žižek comments on this phenomenon in relation to charity barons like Bill Gates and George Soros and capitalist economics at large: quite regardless of whether their multi-billion dollar charity is 'sincere or hypocritical', Žižek insists, 'it is the logical concluding point of capitalist circulation, necessary from the strictly economic standpoint, since it allows the capitalist system to postpone its crisis.'[47] Charity avoids the confrontation with the question of how it became necessary in the first place – and how its causes might be addressed by changing the system.

Marcel Mauss, writing about the anthropology of gift-giving, comments on how in some cultures offerings to the gods and alms for the poor become equivalent calculated sacrifices in the sense that both are about appeasement: appeasing the gods so they don't interfere in human life, and appeasing the poor so that they don't interfere with business. One might say, as Jacques Derrida has suggested in his reading of charity, that the poor actually occupy the position of gods, or of the spirits of the dead; from their marginal position, excluded from the process of production and the circulation of wealth, they always threaten to come back to haunt, to interrupt those processes. So charity attempts to exorcise them. By giving some, but not too much, the threat is held at arm's length and a fundamental distinction is preserved: that between the charitable and the receivers of charity.

There is at least one more level on which the 'Unemployee of the Year' campaign is revealing. Benetton is not just giving away money – they are running a competition, via Facebook, where competing 'unemployees', with their creative projects to find 'new ways into work', are voted for by the (Facebook) public. In Charlie Brooker's *Black Mirror* talent show allegory, '15 Million Merits', competitors for the big prize are the lonely, isolated,

exploited human parts of a technocultural machine that runs on managing their desires (and their pedalling power), and converts any potential challenge into a part of the process. Benetton's campaign has no such power – 'we can't change the world', the chairman humbly admits. Perhaps what continues to be interesting then is that the campaign doesn't quite work – it functions like a symptom: it draws attention to itself, it draws attention to the fact that 100 million unemployed is a problem that has outgrown the capacity of neo-liberal capitalism to reproduce itself. Trying to address it with a social media-based game show format doesn't 'reach out' to young people to show that 'being non-employed doesn't mean being useless, lazy or an anarchist', as their press statement reads. It merely documents a bigger, repressed anxiety.

As tends to be the way with ghosts, gods and spirits, botched exorcisms provoke unwelcome returns. Amongst many recent news items about charity was the announcement that donations to UK universities are up 14% 'despite the grim economic background'. Despite or because of? Whether the gods and ghosts accept the offering remains to be seen.

22. The Deaths of Margaret Thatcher:
Between Spectre and Event

Given that a *revenant* is always called upon to come and to come back, the thinking of the specter, contrary to what good sense leads us to believe, signals toward the future. It is a thinking of the past, a legacy that can come only from that which has not yet arrived—from the *arrivant* itself.

—Jacques Derrida, *Specters of Marx*[48]

Derrida works with a few concepts in *Specters of Marx* which will become important here, in an article which will attempt to fathom the *deaths* – to borrow the term (again from Derrida) – of Margaret Thatcher. *Conjuration, Event,* and *Spectre* (and Derrida distinguishes *spectre* from *spirit*, a concept which might be highlighted by the invocation of a *certain spirit*, such as the obitural spirit of Hunter S. Thompson, for example...[49]).

First, *conjuration*; conjuring, to conjure. There are the senses in this word of *conjuring away* and *conjuring up*, and they are necessarily linked; inextricable, even. One cannot proceed without the other, not in this political climate at least; to try to *conjure away* Thatcherism – and that's what right-minded, left-thinking critics have been trying to do since Stuart Hall gave us the word – is, now, *necessarily* also to *conjure it up*. To conjure up its spectre that is haunting all subsequent governmental policy; that haunts *in, through,* and *by* Thatcher's children, bearing the signs of *inheritance* in the deepest sense ('being-with specters[:] a *politics* of memory, of inheritance and of generations'[50]). In this way, the deaths of Thatcher – from her exeunt from office to passing from life – are, and have always been, spectral. As we know, a spectre haunts – a spectre is haunting the UK – *and that spectre is Thatcherism*. It's not a *legacy*, it's the *demonic*: a *spectrality*.

Second, the *event* of Thatcher was *change* in the political scene,

but change in the most *conservative* sense, so we won't evoke Alain Badiou, but Derrida's thesis on the ghostly again. This is the *event* as the 'question of the ghost [...] the event itself, a first time is a last time. Altogether other. Staging for the end of history. Let us call it a *hauntology*'.[51] Derrida is here citing Francis Fukuyama who uses Hegel's phrase, 'the end of history', to beckon in the capitalist-liberalist utopia in the early 1990s; the best of all possible worlds. But of course it wasn't, and Fukuyama has even reneged somewhat since. But Thatcher didn't, hasn't, would never; she claimed her greatest achievement was Tony Blair and New Labour, that is, to have (re)made the opposition in her own image, to have *changed* their minds so as to have *conserved* her mind-set. The *event* of Thatcher *is* the question of the ghost – the real *enemy within* – the question of what she created, and what has been retained; a true *hauntology*: Thatcherism; its definition.

And last, the *spectre* itself: it comes and comes back. When Thatcher '*personified*' the country – calling its workers, its people, the *enemy within*, and getting their blood on her hands, as well as the crew of the *Belgrano*'s (its sinking being an act of murder the legality of which is still in contention); in nailing the coffin of industry shut; in teaing with Augusto Pinochet and denouncing Nelson Mandela; and in looking on as reaction to stringent sus laws (stop and search) and the homophobic attitude that led to Section 28 boiled over into riotous eruptions – it was as a *spectre* that she did. She *did not* personify the *spirit* of the country, of its people, of its *society*; she did not even believe there was such a thing, and the ghost of that disbelief is its bloated simulacrum, the '*big Society*': inflation.

These are the spectres that live on after Thatcher is buried, and they are the hatchet that won't be buried with her. Official Britain might not find the jubilation at Thatcher's passing tasteful, but that indicates little more than differences between home and foreign policy. The deaths of Margaret Thatcher are

the haunting melodies that have been with us for years: from the music of Crass, Elvis Costello, Smiley Culture, and Billy Bragg, to that of Morrissey, Mogwai, McCarthy and NOFX, amongst countless others; and in the wish-fulfilment of a *strike* over a *stroke*.[52] This death is only the stark reminder of for whom the bell really tolls, and that toll *will* celebrate its dead, its casualties, and its survivors. The Tories may have waited for the veil of death to have explicitly heaped their praises from under, but they are being assured now that such a veil is not a bulletproof vest. Further, in terms of taste, the idea that a leopard changes or loses its spots because of old age or infirmity beckons rather a profound reflection on amnesia, or aphasia (work to be done another time), than one on the past which haunts our future, and from which we can only hope for the arrival of a true *legacy*; an exorcism, indeed.

23. The *Daily Mail*: A Text that Reads Itself

Walter Benjamin regarded the experience of reading modern newspapers as a series of shocks comparable to those experienced around the noise of machinery in factories or the speeding cars in a busy high street. While appearing to present material relevant to their readers in a digestible form, newspapers are actually structured in a way that denies the possibility of assimilating the story to one's own experience and so of making any judgement outside the 'tabloid' (tablet-like) cliché already implied in the text. 'The principles of journalistic information,' Benjamin remarks, including 'freshness of the news, brevity, comprehensibility, and, above all, lack of connection between the individual news items', 'contribute as much to this as does the make-up of the pages and the paper's style.'[53] When I read a newspaper, my attention is always being disrupted: structurally I am in a state of shock.

How can this help us approach the *Daily Mail*, Britain's best-selling non-red top newspaper, and its website version, *Mail Online*? The *Mail* brand is most popularly associated with enraged accounts of immigrants, benefit cheats and the EU, along with scaremongering about cancer, while its readers are habitually caricatured as scornful and paranoid 'middle Englanders.' But this reputation is only justified by a certain amount of the paper's content. On closer examination the majority of the stories, taken in isolation, are comparatively benign, and written in a basically anonymous journalese befitting their anonymous attribution to 'Daily Mail Reporter.' Benjamin can help us here, because in the print version it is precisely the *presentation of the information*, the specific alternating rhythm of outrage, cosiness and health fears, that go to produce its political agenda: an agenda only occasionally made explicit in the individual stories.

It is this benignity in the individual stories – and the appearance of a 'lack of connection' between them – that allows material from the printed paper to sit alongside luridly illustrated accounts of the foibles of minor celebrities on *Mail Online*: a website whose 100 million visitors per month are often far removed from the angry reactionary of the stereotype. The *Mail* has propagated extraordinary success in its online brand by presenting its political content only in such a mode as can be safely ignored by its more diverse online readers should they so choose. It is the pose of benignity in the stories when taken in isolation that makes this possible.

But this is where the function that allows readers to leave comments underneath *Mail Online* stories comes in. Despite the website's different emphasis, the comments invariably appear as a grim parody of precisely the attitudes associated with the printed version. But it is not enough to say that this is simply the existing attitudes of the readers being given a platform. Rather, something more radical is going on. We can say that these comments represent an audacious and violent act of *translation*. They liberate the story from its appearance of benignity, returning it to its true political articulation in tablet form, which had threatened to be lost in the online presentation. So a reasonably neutral story about Halal meals in a prison being cooked with pork receives comments that are Islamophobic and deny the rights of prisoners; a quaint and sentimental story about a large working class family putting on an elaborate birthday party is met with comments about 'chavs' and suspicion over where the money for it has come from; and a story on 'Britain's Most Diverse Street' attracts comments on how all of Britain is, regrettably, going that way. In this way, *Mail Online* represents a development of what Benjamin was observing in the 1930s. It no longer simply imposes its shock effect on us when we are reading it. It shocks itself into betraying its true content at the bottom of the page: it is, finally, *a text that reads itself.*

24. Saint Artist Taxi Driver

Jean-Paul Sartre's *Saint Genet* concerns the French playwright and occasional thief Jean Genet, and at one point claims that it is a goal of his works to lead *'others* to declare that "the thief is a Saint".'[54] That Genet 'ha[d] to steal in order to live' is a contributory factor to this called-for canonisation.[55] The Artist Taxi Driver – the performance artist Mark McGowan's latest and most popular charactorial creation – fervently opposes thievery on the other hand. But a different kind of thievery, State-sanctioned thievery: a theft which, in contrast, he claims, rather steals in order to kill, to inhibit, and to force attrition. The current world-economic situation the Artist Taxi Driver describes as 'not a recession, it's a robbery'; the title of the feature-length film he's planning, of over 50 interviews from inside, or out of, his taxi.

Mark McGowan, through his creation of the character of the Artist Taxi Driver, has been charged with accusations of being a conspiracy theorist, and dismissed on grounds of ranting, but what he is actually providing us with today is an embodiment of Walter Benjamin's call at the end of his famous essay 'The Work of Art in the Age of Its Technological Reproducibility'. Here Benjamin discusses the *'aestheticizing of politics, as practiced by fascism'*, and claims that *'communism replies by politicizing art.'*[56] To find this comment's relevance today we do not have to stray too far: in what's been called George Osborne's 'Wonga budget', we see the chancellor of the exchequer (again) buddying-up to those being ripped off whilst covering up those who are *feeding at the trough* (to put it in the Artist Taxi Driver's words, his favourite epithet of which tends to be 'pig').[57] The aestheticisation going on here is thoroughly modern. This is no longer a beautification of the war machine as it is, such as had been seen in 1930s fascist trends, particularly that of the artistic movement Futurism, but rather a cosmetic correction of its image and

branding in an attempt to render this image appealing to political punters. As Deleuze and Guattari would put it in *A Thousand Plateaus*, it's the demonstration of the reversal of Carl von Clausewitz's famous dictum, to now read: 'politics is the continuation of war by any means'.[58] How seven-day JSA queues and the selling of the student loan book, with the possibility of a retroactive interest-rate *carte-blanche*, will *really look*, of course remains to be seen...

Thus, to all of this, the Artist Taxi Driver's constant barrage of opposition, even in the form of his expletive-laden rants – grounds which those who want to criticise him will dismiss him on – *is* a reply, *as* the politicisation of art. The repeated catchwords of 'pigs, robbery, genociders, etc.', delivered in his informational news reportage slot from his taxi, the 'BBC SuCks O cocks News', addresses the perceivable dearth of such a stance in today's art-world, long noted at least since the days of Bob Dylan's protest songs, or Bertolt Brecht's theatre. Although Chunky Mark – as he has been known in the art-world of the past 20 years – has been around a while, it's this incarnation as the Artist Taxi Driver that brings Benjamin's demand for what art is to do to today's situation, in the most visceral of manners. The manners of a saint? The Artist Taxi Driver is certainly closer to them than to those of pigs, who, in Barack Obama's famous phrasing, it remains the task of the government to 'put lipstick on'.

25. Why are Animals Funny?

Television programmes such as *Animals Do The Funniest Things*, and the animal sections of *You've Been Framed*, have long been part of our cultural life. But the rise of the internet 'meme' and the funny forwarded email has brought with it a more unregulated, more instantaneous culture of the animal, as thousands of pictures of animals are shared every day, to the extent that the popular meme, 'Conspiracy Keanu', wonders 'what if cats have their own internet, and it's full of pictures of us?'

Why should these animals be so funny? The first idea we might apply is what comedy studies refers to as 'superiority theory': we laugh at animals in celebration of our own superiority.[59] But this becomes doubtful when we consider how often animals become funny precisely when they are being most 'human': wearing clothes, cracking jokes, or pulling uncannily human facial expressions.

This is something that philosophy can help with. For G. W. F. Hegel it is the mouth that marks out the animal from the human: 'in the formation of the animal head the predominant thing is the mouth, as the tool for chewing.'[60] The French philosopher, Georges Bataille, agrees with Hegel that 'the mouth is the beginning or, if one prefers, the prow of animals.'[61] For both this is not so for humans, in whom 'it is the eyes that play the meaningful role'.

Perhaps we conceive of the mouth as the central part of the animal because we like to think of animals as driven only by the needs and impulses to eat and drink. As Hegel points out, we also think of each human as containing an 'animal,' as it were. We speak of 'party animals,' 'animal urges,' being 'beastly': not to mention 'chauvinist pigs,' 'sly old dogs,' 'utter bitches,' and 'silly cows.' And repeatedly, we think in terms of a need to repress these supposed animal drives. For Hegel and for Bataille

what differentiates the human from the animal is that for the human the mouth is no longer central; the eyes take over as the central feature. They are the marker of culture, and of trained, learned behaviour rising about the animal.[62]

With eyes come surveillance, recognition, and the ability to regulate one's behaviours. When we start looking we learn to behave as a human. This mouth/eyes and animal/human distinction seems to be supported by three popular funny images of animals: all three are behaving like humans; the first a cat watching the road ahead as its owner is as he drives the car, the second a dog transfixed by an object it is balking from (with the tag 'Do not want!' emphasised underneath), and the third a dog playing with a float in a swimming pool and looking at the camera. All three seem to be behaving humanly with their eyes: even the dog in a rubber ring gazing at us like mother does while she lounges in the pool.

So if there is a radicalism in laughing at these images, it is that the animal-acting-human challenges the old idea of humans determining themselves by their tempering of original 'mouthly' animal urges with the socialising power of the eyes. If the meme reveals that animals too are capable of looking, then their behaviour must be as 'learned' as ours is. It takes an animal to teach us that there is no such thing as natural behaviour: it's all subject to social conditioning.

26. On the Bicentenary of Richard Wagner

2013 is the bicentenary of the birth of the composer Richard Wagner. As was to be expected, opera houses and music festivals across Europe and North America have splashed out on all manner of productions of his ten most famous works (seven if you count the *Ring* as one work). For Wagnerians or just admirers of the music, this has been the cause of much excitement, and the arbiters of official 'culture' have been out in force. The British Education Secretary, Michael Gove has been instructing schoolchildren 'to marvel at the genius [of] Wagner'.[63] One columnist, on hearing that Gove and George Osborne had attended the *Ring* cycle at the Royal Opera House rather than attending to the Liberal Democrat party conference in September last year, remarked that 'Wagner [was] more important than the wretched Lib Dems'.[64]

All this elides what were – for a long time – the main wider cultural references to Wagner outside of the opera house: his association with the Third Reich. For 'dedicated' fans, the bicentenary has provided the opportunity to bring back the real, *proper* Wagner; Wagner the great transhistorical romantic artist, whom Baudelaire called 'the equal of the most exalted and certainly as great as the greatest'.[65]

It is however the desire to use the bicentenary to simplify, diminish, if not to separate the links between Wagner's music and writings and the Third Reich that is most disturbing. And it has determined the tone of the bicentenary. Breaking this trend, a performance of *Tannhäuser* took place at the Deutsche Oper am Rhein in Düsseldorf with a pronounced Nazi-theme. Although the directors said they had meant to '"mourn, not mock"' victims of the Holocaust, an outraged audience booed the performance from start to finish, with 'some opera goers [...] said to be so traumatised they had to receive medical assistance'.[66] The result

was the cancellation of the entire production. Michael Szentei-Heise, the leader of Düsseldorf's Jewish community, thought that the production had strayed so far from the original intentions of Wagner, who wrote it as a romantic opera in the 1840s and set it in the Middle Ages, that it was implausible: "This opera has nothing to do with the Holocaust".[67]

'The original intentions of Wagner' is the key phrase to grasp. It demonstrates that the distaste is in fact not due to the undoubtedly shocking and disturbing content of the production but rather because an opera which is not 'about' the Holocaust is brought into contact with it. Wagner's intentions are not being respected. He is being politicised; his opera forced into odd and uncomfortable shapes by an apparently alien mould.

Can it not be said that it is the *idea* of Wagner as an historical figure which is opposed here? By inserting history in the form of the Holocaust into the supposed ahistorical 'romantic' time of the opera, the production disturbs the safe and recognisable, even reassuring, image of the great composer-genius. The production identifies in the fabric of the opera the implicit connections between the ideological structures present in Wagner's work and the atrocities of the twentieth-century; in Adorno's words, it is locating in the 'self-praise and pomp [...] the emblems of Fascism'.[68] In short, in performing *Tannhäuser* historically, the production refuses Wagner and his admirers the self-image of the ahistorical sanctified artist-genius which he and they desire to construct.

The overriding tone of the bicentenary, seen in the shock and outrage at this production, can be understood, then, as an attempt to 'reclaim' Wagner from history. The bicentenary condones a retreat from the political interpretation of Wagner's work in favour of interpretations which accord with the ahistorical 'romantic' aesthetic laid down by Wagner himself. Instead of forcing the music of Wagner uncomfortably against its ideological products in the form of Nazism or the Holocaust, the

bicentenary promotes a passive experience of 'good art', an experience of Wagner which raises no questions. It is a suppression that is designed to allow Wagner to be consumed without having to interrogate the historical reality in which his music played a central role. Wagner is recast as *Wagner*, the Wagner Wagner wanted to be – free from the constraints of historical time and the politics which followed him – 'the man who [sought] immortality during his lifetime'.[69]

It is the dehistoricizing of a man whose work requires interrogation more than that of others which is the greatest danger during this bicentenary. Surely, it is the historical events which occurred after Wagner's death that make impossible the ways in which he intended his works to be performed. The production at Düsseldorf is alive to this fact, and is an attempt to perform Wagner as part of history, to try to reconcile him and his work with the social reality which followed him and to demonstrate his position in that social reality. The vulgarity of this production, its overwhelmingly traumatic dramaturgy, its essentially anti-Wagnerian aesthetic, is the only way in which Wagner can be performed for us today. Moreover, as Žižek notes in his foreword to Adorno's book on Wagner, this approach 'enables [us] to conceive Wagner's anti-Semitism not as a personal idiosyncrasy, but as a feature inscribed in the very artistic texture of his works'.[70] We are reminded that as much as Wagner is implicated, we too are implicated in our attendance, our enjoyment, even perhaps our admiration. It lets us appreciate the brilliance of the composer without ever making him acceptable. As Thomas Mann so precisely put it, 'music [...] is politically suspect'.[71] During this bicentenary, it is a suspicion we need more than ever.

27. *Moon* and the Eternal Return of the Same

We should preface this article with a spoiler alert which to ignore would entail learning the true meaning of 'once and *for all*'.

'"Alas, man recurs eternally! The little man recurs eternally!"

'I had seen them both naked, the greatest man and the smallest man: all too similar to one another, even the greatest all too human!

'The greatest all too small! – that was my disgust at man! And eternal recurrence even for the smallest! that was my disgust at all existence!

'Ah, disgust! Disgust! Disgust!' Thus spoke Zarathustra.
—Friedrich Nietzsche, *Thus Spoke Zarathustra*[72]

Disgust at all existence! We find this very disgust of Zarathustra's in *Moon*. Nietzsche's concept of the eternal return of the same finds its modern epitome in Duncan Jones' 2009 masterpiece, in which we are confronted with the very unconscious of the world, of existence; with the very virtuality that the eternal return of the same entails in its most nightmarish manifestation: the realisation you're a clone; that your memories are not your own, that they have been implanted for the purposes of keeping enough hope alive in you that you will carry out your work in the dream of getting home and back to whom and what you love, just like Jacob toiling seven years which were but a day for Rachel.

The mirror-stage and imaginary order take on a demonic character in light of this realisation: that haunting disconnection you feel in relation to the mirror image *is* the realisation that *you is another*, to paraphrase Arthur Rimbaud; the uncanniness of the glitches in Sam Bell's telestreams will come to assume their true import. The eternal recurrence of even the smallest man has been

recorded and stored: reset each time, the first time, from the point of awaking in the infirmary, to return to work on the moon's surface, to receive messages from the folks back home, and to be looked after by GERTY. The Sam Bells' fateful realisation after the accident and the awakening must entail in both of them that disgust at all existence that is Zarathustra's; the disgust that from that virtual point of reawakening all potential is and can only be geared towards fuelling the capitalist machine, furthering the recurrence of the Corporation, and that all before that point is the eternal recurrence of the impetus to do so. Despite being science fiction set on the moon this movie perhaps is the best depiction of our world as it is.

28. Symbols of the Working Class:
The Call Centre and Alienating Advertising

This analysis is formed around a personal call centre testimonial, which, despite our collectivity credo, nonetheless remains anonymous, and no doubt connects to many other such experiences in the telecommunications sector, so much so that this fact may even *collectivise* (in the sense of 'universalise') the piece anyhow. Through it we'll aim to fathom something of Marx's idea of *alienation* as it functions in representations of call centre work in television ads. First off, we'll take the example of an advert for an insurance company – or something like that – that was on air a while ago, which ended with an iris-transition (in film, the fade-to-black edit which includes the cut-out circle through which you can still see the central character, as in old cartoons) onto the featured call operative; while we were watching it together, my dad asked me: 'do you work inside one of those circles then?'

A funny jest, but one which touches on this Marxian notion; the question arises, 'what is really shown of the working conditions of call centres in this medium?' The website and pamphlets of the call-handling company I served for six years typically show a plush brilliant-white environment with polished pretty women and suitably suited men sprightlily alert to take your call via pristine top-of-the-range headsets; the exterior shows a glass city tower piercing the sky. The reality of course was a much more crowded room with murkier décor populated by bored-looking ops of all shapes and sizes busily chatting to customers on the ground floor of a business park office in the countryside; all facing their consoles as call after call comes into their ear without choice and without let-up.

Here the call centre labour conditions are alienated from the services the call centre is selling; alienation is even employed in

the call centre's very working method, in that the kindly, helpful and sympathetic voice – isolated in the ear of the customer, on the end of the phone – is alienated from the cramped noisy office in which it actually speaks. Take the new Tassimo advert as another example: it shows an arrogant young call operative in his own spacious cubicle (we were six to a 'pod', or big desk) leisurely giving his spiel with über-chutzpah whilst his mate stands beside him miming the script likewise. The ad gives the popular impression of the job being populated by smarmy privacy-intruders with their heads up their arses; however – and whilst there are plenty of this type – the advert's representation feeds us this popular call centre impression divorced from the actuality of the call centre itself, i.e., *alienated* from the working conditions of the job. (Another condition being, as John McInally puts it, the 'computers [that] dictate the time and duration of breaks, with no flexibility whatsoever', ensuring 'employees are under constant monitoring and surveillance';[73] our monitoring system, in the call centre I was at, being called – with all the ironic lack of irony of the Benthamite company 'Panopticon', analysed by Gemma Moss at adornomental[74] – 'Big Brother'.)

And as, as Owen Jones has put it, today in this country 'the call centre worker is as good a symbol of the working class as any',[75] we must see that this is in part because – like those in the alienated working class jobs Marx identified so long ago – their reality is obscured by the relations of production, that is, this *image production*. As the cuts keep rolling in it's high time to see the condition of the working class in *uncut* form!

29. One Grande Super Skinny Latte with an Extra Shot and Sugar-Free Vanilla Syrup Please!

An Everyday Analysis contributor can often be seen to order a wordy combination of options such as the above in a local conglomerate coffee corporation. The criticisms of such drink selections are familiar; that it is a poncey identity gesture, that it is 'not the real thing', even that it is part of the demonization of the calorie that has come to define our relationship to food and drink in the 21st Century. All of these are fair criticisms in their own way, and yet if one looks at the structure of this desire, something more is revealed about our relationship to food and to our bodies.

The first point is the excessive nature of the American-style coffee; the size of the cup (perhaps epitomized by Starbucks), the number of shots of coffee (Café Nero) and the amount of milk exceeding your RDA of protein (certainly Costa). Then we add sugar or sweetener, chocolate, cinnamon or vanilla dust, and a shot of flavoured syrup, perhaps even cream. The whole process, masquerading as 'choice' ('we can make your perfect coffee') is really an injunction to drive towards excess ('make sure there is enough/too much of everything in your coffee!').

But what happens when we take out all of the 'bad' content of this excessive gesture; the fat, the sugar, and anything that would need to make us feel 'guilty'? Surprisingly, very little. The enjoyment does not disappear, or even appear significantly reduced. The explanation that we enjoy this excessive consumption precisely because it is harmful, as if it were a kind of Death Drive, seems insufficient. We are essentially drinking nothing, but we derive a similar enjoyment from this as we would from gorging on piles of full-fat chocolate and pints of full-fat milk and cream.

Of course, disavowal is a part of what is in play; 'I know very well that there is no content to what I am offering my body, but even so, I can enjoy feeling as though there is.' We all know that this drink is not 'the real thing' and that is the point.

But there is something more too. This reading shows the subject's desire to make a split, perhaps a very clear one, between mind and body. And further, it does this in two completely contradictory ways.

In the first case, I want to believe that my body wants to consume a huge cup of sugary milk, and so my mind has to trick it into believing that I have given it what it wants. Here, the mind is in on it, committing disavowal, and tricking the body into feeling gratified with this ersatz calorie-free alternative. In the second case, happening at the same time, is the absolute opposite. I see my body as a 'temple', a pure and uncontaminated space. I recognize the cultural need to consume American-style coffee, placing the mind in the position of the subject-who-desires, and I instead need to gratify this cultural or social desire without contaminating the purity of my body; the body is in on it, the mind is fooled.

In the large skinny latte with extra coffee, fat-free cream, sugar-free vanilla syrup and an extra shot of espresso we see the simultaneous satisfaction of two contradictory ways in which 21st century culture conceives of the body. We are able to see our bodies as naturally desiring excess and consumption (excusing our role in consumer capitalism) and we are also able to see our bodies as natural uncontaminated temples which we need to preserve against the world (also the logic of capitalism). If we look closer at these structures we start to see that both these views of the body – both of the body-as-natural – are part of capitalism's own contradiction, and therefore cannot be seen as natural at all.

30. Why Justin Bieber Should Listen to Neutral Milk Hotel

In Amsterdam's Anne Frank Museum's guestbook Justin Bieber left this now highly-publicised message after his recent visit: 'Truly inspiring to be able to come here. Anne was a great girl. Hopefully she would have been a belieber.' Jean Baudrillard suggests that the Holocaust-denial 'statement 'It never existed' means simply that we ourselves no longer exist sufficiently even to sustain a memory, and that hallucinations are the only way we have left to feel alive.'[76] There is a tremendous implicatory force in this suggestion, one aimed at our muddledly mediatised (*mediated by the media*) culture as a whole. The essay in which this phrase appears is called 'Necrospective' and this seems precisely to be what Bieber has applied to Anne Frank's memory, specifically through a formidably strange hallucination which ties completely non-parallel, utterly asymmetric continua together with its knottiness.

Postmodernism might offer us another word to suggest why so: 'hyperreality'. Bieber's bubble here seems the product of the hyperreal age he has come out of, or even that he has come into; that he is a part of (and that he perpetuates, and that he perpetuates indefinitely; this indefiniteness being a hallmark of the *postmodern condition*). There is some link between this 'hyperreality' and hyperactivity; *activities* – visiting cities' museums and heritage sites alongside their themed retail outlets and amusement parks – being something that people now '*do*' – in the most touristic sense of the word – and which competitively require manifold consumerist intensifications to hold appeal.

One such hyperreal intensity might be found in Washington DC's Holocaust Memorial Museum's ID-card tour, which – as Richard Appignanesi describes it – 'match[es] your age and gender to the name and photo of a real Holocaust victim or

survivor. As you progress through 3 floors of the exhibition, you can push your bar-coded card into computer stations and see how well or badly your real life subject is faring.' …'At the end,' he tells us, 'you'll find visitors' ID cards dumped in litter bins among the pop bottles and chocolate wrappers. Your hyper-reality tour is over.'[77] Whilst the effects of this mode of presentation and of learning must flit for visitors between uncanny feelings of discomfort, awe and surrealism, the Aristotelian notion of catharsis can only look shamefacedly on at the Bieber-type experiencers.

What makes this affair weirder, however, is that the Anne Frank Museum isn't as hyperreal as all that, rather it is quite starkly 'real-ised' in that if it's not the original fittings and fixtures that occupy the house it's facsimile ones (the wallpaper is marked 'facsimile', for example). So it must be that Bieber's very reality itself *is* a form of hyperreality; a hallucination so all-encompassing that he can claim through it that 'Anne was a great girl', and hope that she would have joined him in his *make-beliebe*.

His hallucinatory sentiment only reminds us 'that these events are on the point of escaping us on the level of reality' – as Baudrillard highlights[78] – and of the dangers of this. It doesn't draw some sort of poetical thread through time like Jeff Mangum's lyrics throughout Neutral Milk Hotel's *In the Aeroplane Over the Sea*, an album the pop star should be directed to…

Adorno's reflection before he announced that 'to write poetry after Auschwitz is barbaric' was that 'even the most extreme consciousness of doom threatens to degenerate into idle chatter',[79] which with Bieber it has. In Mangum's words, however, there remains something more pertinent, and which resists this idol's idleness: 'I know they buried her body with others/Her sister and mother and 500 families/And will she remember me 50 years later?/I wished I could save her in some sort of time machine/Know all your enemies/We know who our enemies are' ('Oh Comely').

31. More on Justin Bieber and Anne Frank

The Everyday Analysis article above treated Justin Bieber's recent visit to the Amsterdam Anne Frank Museum, in which he now-famously wrote in the guestbook: 'Truly inspiring to be able to come here. Anne was a great girl. Hopefully she would have been a belieber.' The article takes issue with what it sees as a particular facet of postmodern culture; the way that we imagine that completely distant and unconnected events can somehow be paralleled, so that Anne Frank can be thought of in Justin Bieber's terms. Part of the problem the article highlights is the imaginary way in which we see our world; if everything can be thought of in our terms then the otherness of the past is denied, and the way we think now appears to be inevitable. By extension the article shows that Bieber's comment highlights that our culture 'doesn't draw some sort of poetical thread through time' by using Anne Frank for any political purpose. Instead it depoliticizes, by assimilating the past into the terms of the present.

These points are important ones, and yet, I want to suggest that there is perhaps something else that Bieber's comment shows us about our culture, which is both more just to Bieber's misjudged but not truly evil remark, and which also picks up on something not noted by most of the critics, showing us something about our own response to the Bieber-blunder.

Interestingly, a number of people have come to the defence of Bieber over the comment, which first drew a large amount of criticism when it was published via the Museum's social media sites. Anne Frank's step-sister, Eva Schloss, has even commented that Anne 'probably would have been a fan' of Bieber, saying; 'he's a young man and she was a young girl, and she liked film stars and music.'[80] Schloss implies that being a teenager is a timeless state outside history and therefore brushes over the historical chasm of the Holocaust genocide that separates Bieber

and Anne Frank. The question I would like to ask is: what is it that fundamentally divides these two responses; on the one hand the view that the article puts forward, which stresses the problem with assimilating Anne Frank into the life-world of Justin Bieber, and on the other hand the view of Anne Frank's stepsister, which cannot think otherwise than in the terms of the present?

Remarkably, the *Sun,* reporting on the Eva Schloss statement, actually carry out the same gesture that has been highlighted by the article above. They open by referring to 'teen titan Justin Bieber' and then later to Anne Frank in the same terms, saying 'the teen hid from the Nazis'.[81] The *Sun* should have at least some kind of awareness of the issues involved here. Likewise Eva Schloss, who has written a historical book called *After Auschwitz,* seems to be participating in a discourse of assimilating the past into the terms of the present, rather than reflecting on the issues of historicity that are being raised by Bieber's comment.

This leads to the main point I want to make here – that we might 'save' Bieber's comment from the critics, in a very different way to Will.I.Am, who claimed on the subject that 'there is a lot of shit to do in Amsterdam but he chose to go to Anne Frank's house.'[82] The difference between the *Sun* and Eva Schloss and Bieber's comment is that Bieber's remark is, at least in a way, a joke, whether he is entirely in on that joke or not. The 'selfish' element of Bieber's comment, that he focussed on himself even when faced with the trauma of Anne Frank's life and death, marks a subtle difference between himself and the *Sun,* who carried out the same gesture accidentally whilst believing themselves to be objective, or even Eva Schloss, who couldn't see 'why not?': 'Why wouldn't Anne be a 'belieber'?' Bieber's anachronistic remark acknowledges the limits of our own socio-cultural-historical-subjective positionality; it acknowledges an issue of historicity that the *Sun* and Schloss ignore, that he can

only 'read' Anne Frank in terms of his beliebers.

Bieber's comment, to return to where we began, shows us that we cannot read the past except in our own terms, so that the idea of 'authentic' access to the past is shown to be a problem. Bieber makes a point made academically by Catherine Belsey when she writes that 'we bring what we know now to bear on what remains from the past to produce an intelligible history.'[83] For Belsey, to read the past, to read a text from the past, is always to make an interpretation, which is in a sense an anachronism.

The 'belieber' comment, very strangely and no matter how unconsciously, has a sense, in its anachronism, of acknowledging an issue of historicity that the majority of responses, from the *Sun* to Eva Schloss, are lacking. Where Bieber makes no pretences of 'knowing' history outside his own subjectivity, perhaps his comment points to a dangerous tendency of critics to think that they can. Or perhaps even further, that in insisting on the impossibility of accessing the past, in attempting to distance Anne Frank from Justin Bieber, some readings ignore the fact that a radical otherness of the past is found in acknowledging its creation in representation by the present. Instead one ought to acknowledge as Bieber does, in a way that points out a problem with Baudrillard, that representation is always hyperreality (the inability to distinguish reality from the simulation of reality) whether we are dealing with postmodernity or not. While the past, the real conditions of Anne Frank's existence, is real, the question of how history should be written and read must also come up against the Bieber in us, we can neither access that past nor preserve it from contamination by the present.

32. Pushing the Skies' Limit: *A Life in the Day of The Flaming Lips' '7 Skies H3'*

'In music the only possible abstraction possible is the sense of TIME-SPACE, and its relation to the human body through the organ of the ear; through the spacing-off and draughtsmanship of TIME-SPACE by the means of various points of sound.'[84] This is clause VI of George Antheil's manifesto, 'Abstraction and Time in Music'. In so many ways The Flaming Lips have taken these theses as points of radical departure with their 24-hour song '7 Skies H3'. 24 hours is no arbitrary track length, but one that reinforces the very insistence and modality of time itself, in music, as in life, as in death (on which the song is purportedly a meditation). As we find in a line of its lyrics – 'now, a minute's not a minute, and now, an hour's not an hour' – we're met with a concentration on this (still-)radical *NOW*; the moment in its simultaneous *contiguity with other moments*, and *continuity within in time*. 'Now' is a concept so important throughout modernist and avant-garde movements in art, not least to 'Nowism' itself, and it is mediated here through a reflection on common temporal measurement – units of time – that become less easily, immediately and complacently graspable as quantifiers of music as we move from the minute to the hour to *the day*.

As James Joyce's novel *Ulysses* is, in so many ways, a life in the day of, so is this: a radical reconfiguration of what we conceive of our day being is demanded by the endeavour of listening to this track, in relation to the most basic constituents of sleep and waking, meal times, *routine*: our very diurnal spatiality is (momentarily) revolutionised by this piece of music; it trans-forms (our) TIME-SPACE itself. The necessity of it inhabiting our day spatialises its temporal presence too; rest assured, it will really get into your skull: to have it on for the full 24 hours is to simultaneously enforce the very idea it is also a meditation on –

in its links with death – *repetition*, and its compulsions; desire, continuance, recirculation: 'I can't shut off my head', as Wayne Coyne sings.

Of course, one doesn't have to listen to it in just one sitting, so to speak. It can be chopped up into segments – or 'bitesize chunks' (to put it in old BBC secondary school revision speak) – or even delved into at will: listened to systematically bit by bit, or randomly; *whenever, wherever*. Stretching these spatio-temporal possibilities even further is its endless repeated circular streaming online: log on, tune in, drop out, *whenever* – temporally, it's almost limitless; it's always there, repeating; *wherever* – spatially it's as almost-limitless in that it's accessible from a multitude of points of modern connectivity and mobility; so many technological devices.

As an instance of recorded sound it is extraordinarily audacious; a humongous work, in terms of length *and memory*; a timely avant-garde exploitation and exploration of the technological means by which it becomes a possibility *beyond imagination*: the skies have become the limit in terms of electronic recording and its equipment. There is thus something anti-commidificatory about '7 Skies H3' too, in its redefinition of materiality, or material parameters; yes, it was made available physically on a USB drive encased in a human skull – 13 of which were made and sold for Halloween – at the immodest price of $5000, but it's also streaming in its nonstop form online, and can be found here and there to download in its entirety.

Thus overall, from the pounding two-two pummels and monk-chants of roughly hours 2 to 4 to the ecstatic beauty – cut-in on by awesome guitar-slice sublimity – of the section approximating hours 14 to 18, this song pushes at the very borders of art, and in doing so, also at those of time and space, of the human body, and its materiality and condition. In so doing it forces us into an intense concentration on – and in – our own skulls; one that hasn't been quite as insistently, and yet never as *temporally*,

realised since Samuel Beckett's radical fizzle 'For to End Yet Again'.

33. 'Drink Responsibly' and the Limits of the Infinite

A current anti-excessive drinking campaign shares a strange quality with the alcohol adverts to which one would expect it to be opposed. The Drink Aware poster displays three young men on a night out, with the caption underneath 'Where will your night end up?' A label is attached to each 'lad' in the photo. Above the first it says 'Bar24,' above the second 'Gav's place,' and above the third, 'intensive care.' The message is clear enough: drink responsibly and you will have a great night clubbing or hanging out with mates, or drink excessively and risk ending up in hospital.

But something more is shown here about the way in which we see drinking in our culture. The poster shares something with alcohol adverts themselves in that it connects alcohol with a kind of infinite possibility, an 'anything could happen' attitude; 'you drink, and who knows where your night will go...' Many adverts work in this way, but alcohol marketing specifically preys upon this infinite possibility, its link to escapism, an entry point into another world of experience, the *unknown*. Take for example the latest Bulmers campaign, tagline: 'we don't know where your night will end up, but it will begin with a Bulmers.'

Yet, what we are dealing with here is not really the appeal of the infinite unknown at all, but rather the writing and mapping of the infinite by ideology. What this Drink Aware campaign shows us is that when we talk about possibility in this way we are not really dealing with the unknown, but with the role that the unknown plays within the limits of our knowledge.

In the Drink Aware poster possible destinations are predetermined, and we could easily go down the route of seeing just how much they signify: 'bar24' might imply all night partying in a place at least newer than the 24 hour drinking laws, 'Gav's place'

might imply spending the night with mates to whom you are close enough to have a nickname for. This predetermination of the unknown is, however, a feature of alcohol adverts as well; a glass of Russian Standard Vodka might lead you to very mysterious and unfamiliar territory indeed, but that unknown predictably tends to be a Moscow nightclub filled with attractive women and talented dancers.

The point here is not that, despite whatever we may desire, we are limited to a predetermined list of possibilities. On the contrary, the point is that our desires are themselves channelled and determined by our culture. And alcohol adverts are a point at which this becomes apparent. In their attempt to appeal to the 'unknown' and the 'anything can happen' attitude, they show us how our conceptions of the unknown are actually always finite rather than infinite, they are always culturally determined in often very specific terms. Ultimately what we see here is that whilst we like to think that our desire is for change, innovation, the new and the unknown, what we really mean by these terms is a fantasy very much known and constructed by our commodity culture. What this means is that we cannot see desire as having a natural drive towards some kind of change-as-such, since we have to see that change itself as culturally constructed.

34. This Charmless Man:
The Artist's Message and its Disavowal

According to Octave Mannoni, the psychoanalytic term 'disavowal' fits into the formula: 'I know very well, but all the same...'. It is a coping-mechanism for life; in the most general schema it runs: 'I know very well that life is finite – not only my life, but *all* life – but all the same I carry on with things...'.

But the disavowist also becomes particularly odious in certain situations: the suit rocking out in that late-night city bar to Jimi Hendrix's 'All Along the Watchtower', hearing Dylan's lyric 'businessmen, they drink my wine', and swigging back their cabernet sauvignon regardless; the 'more-knowledgeable-(*and-more-white*)-than-thou' history grad who 'corrected' Chuck D's disquisitions on the history of black suppression at Public Enemy's *Fear of a Black Planet* Don't Look Back gig last year, for example... Kurdt Kobain included this warning in Nirvana's *Incesticide*'s liner notes in 1992: 'if any of you in any way hate homosexuals, people of different color, or women, please do this one favor for us—leave us the fuck alone! Don't come to our shows and don't buy our records.' Those who match these profiles, whilst nonetheless belting out the likes of 'Hairspray Queen', thus fit the disavowist bill also.

And now David Cameron's in on the act too, patently disregarding Johnny Marr's claim that he shouldn't be into The Smiths' 'This Charming Man' because the band '[a]re not his kind of people' and avowedly (i.e., *dis*avowedly) ignoring the cease and desist tweet injunction: 'stop saying that you like The Smiths, no you don't. I forbid you to like it.' Surely, Blur's 'Charmless Man' is more suited... It is in that smug faux-cheekiness of Cameron's manner, in defiantly continuing to listen, that the pointer to his disavowal in the Mannonian mode becomes apparent, as does the distinction between irony and disavowal.

He is not doing this *ironically*, he knows full well The Smiths aren't his kind of people, but all the same... Of this type of disavowist we wonder: could there be an any less charming man?

35. 'Change Your Life': *An Analysis of Little Mix*

'Change Your Life' is the latest single by the girl-band Little Mix, winners of the 2011 series of *The X-Factor*. It is a song that tells us an awful lot about ourselves. 'Change, change your life, take it all' the chorus commands, reminding us of what we already know: our current life is insufficient, it lacks something. The song is an inspirational one however, as the swelling chords indicate, and it does not want to suggest that there is a problem with our identity – with who we *really are*. Our life may be lacking but *we* are not: this is the song's message. For this reason, the command to 'take it all' is followed by the line 'you're gonna use it to become what you've always known'. 'Taking it all' is not consumption for its own sake: it is a means – perhaps our only means – of self-realisation. 'Taking it all' enables us to bring about change, and change is required, paradoxically, to *become what we've always known*.

This takes us to the kernel of the song: identity. Identity in this song is not what you are, but what you want to become. At the same time, it is determined by 'what you've always known'. 'What you've always known' must be distinguished from what you learned when you were very young – it is more radical than that. It is the category of whatever goes unquestioned, whatever does not even enter into thought. We must also recognise that, if becoming it requires you to change your life, then 'what you've always known' is *that which you are not*. It is a knowledge which is not yours. A gap opens here, which is precisely the gap in which identity is constituted. Marxist theories of ideology call this gap alienation. For Lacan, it is the gap that emerges in the mirror stage when the child identifies with an image of herself. The problem is that any image with which we are forced to identify is always insufficient, as the first line of the song reminds

us: 'She captures her reflection then she throws the mirror to the floor'.

Yet this song is also a story about *Little Mix*. They are the ones who have changed their life, winning a talent contest and achieving success in the charts. They are telling us, in this song, that *they* have become what they've always known. It is a celebration of self-achievement. The song turns against itself, however, with the recognition that 'what you've always known' is not identity but rather the ideology or Symbolic order that precedes identity. What *Little Mix* are saying is that they have become embodiments of the system which tells us that our lives are incomplete (and in the telling makes them so). Instead of returning to a true, original identity, Little Mix have become images which show us that identity is separated from life. The song says this: if you've always known that your life needs changing, then follow Little Mix's example and become the means by which this knowledge is perpetuated and disseminated. The success of 'Change Your Life' is that it turns this position of absolute alienation into one of affirmation.

36. Angry Birds and Postmodernism

The mobile phone game sensation Angry Birds needs little intro-duction. Released in 2009, the game has sold (including free versions funded by advertising) clear of 1.7 billion copies across mobiles, video game consoles, laptops and PCs. To put that in context, the first and most popular Mario game sold only 40 million. There are nearly 7 billion people in the world, so one quarter have played Angry Birds. You can buy Angry Birds toys, t-shirts, lunchboxes, pencil cases, and nearly everything else. What is behind this sensation of mobile phone games, of which Angry Birds is most certainly the epitome? And what is it specif-ically that makes Angry Birds more popular than the others? What is really behind our enjoyment of this game?

The first of these questions can be answered by a version of Baudrillard's concept of 'hyperreality.'[85] Baudrillard's criticism of post-modern culture, which he sees as epitomized by Disneyland, is not simply that it is 'fake,' but rather that in presenting itself as the world of imagination and fiction, it implies the existence of a more 'real' 'authentic' experience outside of this world of signs and symbols: a pure and genuine 'reality.'

When we play these games (on trains, buses, at work, in waiting rooms), viewed by almost everyone as a tempting distraction from real stuff, we partly enjoy doing so on the level that the associated guilt actually re-enforces our sense of being very important people with 'much more important things to do.' The distraction supplements that from which we secretly want to be distracted, allowing us to feel that what we 'should' be doing is truly 'worthwhile.' Indeed, David Cameron, a man who must have anxieties about the worthiness of his work, has completed the game…

Though Angry Birds exemplifies this, such points might be

made about all sorts of games. Moving to the second question, that of what explains the specific success of Angry Birds, we have to see that this coherent idea of 'real life' which in this model the distraction is supposed to affirm, itself becomes blurred and incoherent.

This is something picked up on by Walter Benjamin, also speaking of modern life, when he coins the phrase 'culture of distraction.'[86] But for Benjamin distraction is not simply a matter of a deficit of attention which distracts from an otherwise stable reality, but instead implies a scattering or dispersion, which he sees as constitutive of modern mass culture. Anticipating Baudrillard, Benjamin explains how the individual is bombarded with signs so that no coherent reality can be found, the individual self and its reality become fragmented and scattered because there is so much distraction that there is no normality to be distracted from. So how does one survive in these conditions? One plays Angry Birds, which we now see is a text which needs detailed close-reading.

In the game, your characters are a set of angry birds, who launch themselves at the 'bad guys,' a set of green pigs. The pigs are in a structure made up of wood and bricks, which needs to be knocked down to get to and destroy the enemy pigs within. Some of these are small, a single house, where others seem to resemble a metropolis. In short, the pigs are inside, the birds are out. So the birds (which we imagine we are, which children pretend to be in the playground) represent the dream of standing outside the structure, or the city, and bombarding it. The point is that we as modern subjects, as Benjamin explains, feel like the pigs; we are inside the structure, being bombarded with signs that threaten all coherence of meaning and who we are. We cannot make any sense of these signs, lost between illusion and reality, and so we construct a fantasy in which there IS something 'behind' those bombardments, some agency, something controlling the signs/birds. In the game this is us, behind our

iPhones; in the game, we are the outside controlling force that is absent in the world. Angry Birds is the epitome of a culture of distraction, but it also responds to it. The pigs have less to worry about than us, because at least there is something 'out there' controlling the signs hitting their city.

37. Manning Up

It is a phrase which has become ubiquitous in recent years. 'You don't feel like having another beer?' 'Man up.' 'Crying because you've just been dumped?' 'Man up.' 'Worried about a difficult conversation?' 'Man up.' The interesting thing about this phrase, though, is that no-one ever has to have it explained to them. It's obvious. To man up is to be (more) like a man. What's difficult about that?

But it is precisely the obviousness of the phrase which makes it so compelling as a comment on our contemporary sense of gendered identity. And because it is so obvious, so blunt even, it is easier to use the phrase in an ironic or tongue in cheek way. In this sense, 'man up' can even apply to women. 'Stop complaining, be stoic, be like a man.' As this (mis)use indicates, there is a contradictory doubleness or duplicity within the phrase, whether applied to men or women, which needs to be unpicked. Judith Butler, drawing on the work of Monique Wittig, points out that popular discourse about gender, and traditional philosophy, both assign it the quality of 'being'.[87] Your gender is what you are, whether you like it or not. This 'fact' is what allows us to utter the apparently unproblematic statements 'I am a man' or 'I am a woman'. Language demands that we make this statement about those around us every day, almost with every utterance, whenever we say 'he says' or 'she says'. The phrase 'man up' seems solidly part of this tradition, assuming a fixed, knowable core to manliness. It is clear what it means to be a man, the phrase tells us: it is an absolute and unchanging essence, firmly ensconced in the realm of the ideal. This is why the phrase operates as a convenient shorthand; indeed, why it can be used at all.

At the same time, 'man up' expresses the injunction that we must become a man, telling us as directly as possible that we are not one yet. In this sense, it operates like the famous Aretha

93

Franklin lyric picked out by Butler: 'you make me feel like a natural woman'.[88] Franklin does not tell 'you' (the man) that he makes her into a natural woman (the corollary of the 'natural man' of 'man up'), only that he makes her *feel* like a natural woman. This subtlety of phrasing indicates that the concept of the natural woman (or natural man) is fundamentally alienating, enforcing gender identity as an ideal which it is impossible to attain. This is why for Simone de Beauvoir one is not born, but rather becomes (or, we might add, does not quite become) a woman. Gender is not being but becoming. Nevertheless, 'you' make 'me' feel like a natural woman. For Butler, the man enforces gender on the woman here as difference (from himself). In the most negative reading of this relationship, we might say that the man imposes upon the woman both the necessity of attaining her 'natural' gender identity and the impossibility of ever achieving more than a simulacral approximation of it. Her gender identity must therefore always be one of absolute alienation, something which she is never allowed to forget.

With the phrase 'man up', all of us can now take part in a similar process. We all know what it means to be a man (even if, like St Augustine, we can't precisely define it when challenged), but we also implicitly recognise that every time we say 'I am a man' (if we do) the impossibility of positioning gender as being forces the statement to turn back against us, responding 'you are not a man'. What the phrase 'man up' allows, and the reason why it is always self-ironising, is the ability to point out the alienated identity of those around us, and at the same time of ourselves. Using the phrase makes us into the 'you' of Aretha Franklin's song, telling the other that there is such a thing as a man, but that you (and I) will only ever be in the process of becoming, and will never actually *be* it. We know every time we use the phrase that it is an impossible injunction – it is the injunction of gender itself – but this is why we revel in it. The impossibility does not stop us using it but rather encourages us to use it again, and again, and again.

38. From Restricted to General Onanism: *Bataille and the Personal Massager*

The (very) British catalogue *Solutions World*, whose target demographic is the 65-110 year-old middleclass dupe (i.e., the poor soul who still uses phone-in mail-order systems, and who doesn't have family or friends who are online to warn them of the at-least-300% mark-up on all of the catalogues' products), promote a vibrating dildo under the name of a 'personal massager', with a photo of a woman, in all seriousness, massaging her neck with this obvious phallic pleasurer, and with this write-up:

> After a hard day at work we could all benefit from a relaxing massage but few of us can afford the one-to-one attention of a professional masseur. Now you can ease away everyday tension and stress in the complete comfort and privacy of your own home with this personal massager, suitable for every part of the body, to bring you the satisfaction of a deep, sensual massage.[89]

Something is fishy here, but how should we approach figuring out what it is? First, let this demonstrate the necessity of not always reading the world straightforwardly; imagine the scene of Marge returning home: 'Oh, I've had such a hard day at work dear, pass us the personal massager…' Is this what we're meant to see? Perhaps not.

Georges Bataille argues in *Eroticism* that the move from 'animal nature' to the human realm came about 'by working, by understanding […] mortality and by moving imperceptibly from unashamed sexuality to sexuality with shame, which gave birth to eroticism'.[90] Here we have an instance of extremely shame-faced sexuality, disguising its truth with such a double-bluff that

it is the obviousness of this attempt to obscure the object's sexual function that is its true obscenity, appearing more obscene than any description of the massager's pleasure-giving properties would have, despite how it might have jarred with the catalogue's other supposedly prim and proper products and its demographic's sensibilities. So, through this sexuality – as much *shamed* as it is *ashamed* – we have not moved into eroticism; the massager has not been eroticised. Nor has it been sublimated in the Freudian sense: the 'exchange [of an] originally sexual aim for another one, which is no longer sexual but which is psychically related to the first aim'[91] has not really taken place; there is something in the obviousness of its onanism – a '*personal* massager' for those that cannot 'afford one-to-one' contact 'after a *hard* day at work', 'relaxing' you in 'the privacy of your own home', 'bringing you to a deep and sensual satisfaction' – that implies something more of an awkward short-circuit.

Perhaps then – and most likely unbeknownst to *Solutions World* and its intentions – the representation of this 'personal massager' is a radical indicator of something more fundamentally intrinsic to the real of sex; that is, the impossibility of its linguistic representation. Bataille says towards the end of his book, in an echo of Wittgenstein: 'eroticism, perhaps the most intense of emotions, is as if it did not exist as far as our existence is present for us in the form of speech and language [...] eroticism must remain something exterior[.] Erotic experience will commit us to silence'.[92] Whereas something like Bataille's notorious novella *Story of the Eye* might, despite this, nevertheless attempt *to voice something of sex's existence*, the whole rigmarole of this 'personal massager' seems rather *to vocalise its necessitous silence*.

39. Fear and Anxiety in *The Gruffalo*

We usually think of anxiety as being caused by fear; we feel anxious because we are scared of something or because we worry something might happen. We speak of feeling anxious 'about' something or of something 'making' us anxious. A strange man hanging around outside our house will make us feel anxious, because we fear what his presence might lead to.

Freud argues in opposition to this that anxiety cannot be seen as an anxiety of something or because of something. For Freud this makes anxiety different to fear or phobia. A phobia, Freud says, is in fact formed as a response to anxiety. The phobia or fear centres unplaced anxiety around an object. Through this process 'an internal, instinctual danger' (that of unplaced anxiety) is replaced by an 'external, perceptual one' (that of fear directed at a particular object) and this allows the subject to stop feeling anxious. Anxiety exists first; we deal with it through fear.

This seems to change the way in which children's stories about monsters need to be read. In this reading it is not that we transfer our fears and phobias of real things (murderers, paedophiles, terrorists) into the imaginary figure of the monster-under-the-bed, but rather that we create a monster in order to create fear, to feel that there is some external 'thing' to be scared of, so that we do not have to face the more foundational anxiety within ourselves.

But doesn't *The Gruffalo*, the famous children's story written by current Children's Laureate Julia Donaldson in 1999 – which has heralded a major series of books, television shows and theatrical productions – take this one step further?

The first half of the story represents exactly what we have seen through Freud. A mouse takes a stroll through a deep dark wood, and is approached by three predatory hostile figures; the fox, the owl, and the snake. Each tries to convince the mouse to

come into their homes, so that they can eat the mouse. The mouse tells each of them that he is going to have lunch with a 'Gruffalo' and describes the horrible monster to them, saying that its favourite food is 'roasted fox', 'owl ice cream' and 'scrambled snake'.

The mouse creates this ultimate scary image of the monster (description of whom takes up one third of the book) not out of the things he really fears – it shares no characteristics with the fox, the snake or the owl – but instead as something so completely 'other' that he does not have to face anything which is really threatening to him. Each time the mouse fools his predators he remarks:

Silly old fox/owl/snake, doesn't he know?
there's no such thing as a gruffalo!

The mouse is able to deal with the potential 'fear' of the Gruffalo because it does not exist, and this allows him to escape any more serious anxieties, to escape the anxiety of his real conditions.

Then, at the midway point of the book, the story takes an interesting turn. Where we expect the mouse to sit down and enjoy his lunch, having fooled his enemies, the Gruffalo actually appears. At the very moment that the mouse has turned his anxieties into a fear that he can deal with, this fear is realized. The statement is that in dealing with your anxieties by producing an imaginary 'Other', this imaginary Other is really and truly produced when it did not exist previously.

But, The Gruffalo has a third turn, and this third movement is the one which makes the story truly radical. Rather than being eaten by the Gruffalo (or having to run for his life to safety, which would amount to the same thing in more child-friendly terms), the mouse is able to control the Gruffalo by pretending he is 'the scariest' creature in the wood. The mouse marches back past the snake, the fox and the owl, each of whom run away screaming

because of the Gruffalo (who doesn't realize that he is the scary one). Having proved his dominance over the wood, only then can the mouse do away with the Gruffalo, stating 'now my tummy is beginning to rumble, and my favourite food is Gruffalo crumble.'

Isn't this one of the most radical assessments of Western culture that contemporary literature has produced? The West (represented by the mouse) deals with its internal and real anxieties (represented by the snake, owl and fox) and now walks safely through the wood, with an imaginary Other which it has created (represented by the Gruffalo) beside it. The West appears to be the only thing which can control the Other which it has itself created, and this allows it to dominate over the rest of the woods. The West may even be the smallest and physically weakest creature, but it has control over ideology.

40. *Consumero ex nihilo*: 'Air is Part of the Recipe'

Jacques Lacan at the start of his seminar on *The Ethics of Psychoanalysis* states that desire 'is always desire in the second degree, desire of desire.'[93] He then discusses how 'the value of a thing is [in] its desirability[;] the point is to know if it is worthy of being desired, if it is desirable for one to desire it.'[94] He here locates this valuative assessment on the plane of the imaginary order, meaning that this kind of desire – dictating taste, valuation and judgement – takes place in the imaginary (or, in our imaginations). Our imaginaries in this respect are of course fed by consumerism, by the stories that are told to us about the products that our sold to us: in the case of the 'grande super skinny latte with an extra shot and sugar-free vanilla', discussed above, we see two dichotomous views of the body – as craving excess and seeking to preserve itself as a temple – satisfied in one consumerist combinatory.

The ideological stories that we symbolically receive through consumerism – and the ideological images that shape our imaginaries in response to it – are craftily connived to make us desire desires that are not only constantly changing (to keep us constantly craving the new), but that are beneficial to consumerism itself in more direct and inflationary ways. Note how the narrative has changed since the 1990s in terms of our diet soda drinks; the excitement that came with the introduction of Pepsi Max in 1995 was brought on by its association with maximalisation: its lack – containing minimal calories and being sugar-free – was positivised as a maximum, the max of taste, energy, possibility, and *joie de vivre*, as it was depicted in its adverts.

Ten years later we have the introduction of Coke Zero, also low on calories, but now touting a different message: less is more;

it's zero, but you want it... it's zero, *and that's why you want it*. Originally designed to promote a diet brand to a more masculine audience (as Diet Coke was apparently associated by men with women), it is nonetheless portentous that this branding came about in the build-up to the burst of the maximal bubble. 7Up Free came along a little later (after the credit crunch) and continued this narrative of 'less is more', willing and wanting zero, willing and wanting free, in the age of austerity. The drive is not towards a desire to passively desire nothing – i.e. to not desire, to renounce desire – but towards a desire to *actively desire nothing*: towards what we could call a *consumero ex nihilo*. (And, all the while, for consumerism itself – and its capitalist spoils – less really does become more.)

At the ODEON cinema an employees' mantra is that for popcorn 'air is part of the recipe'. That's the reason they'll give for portion-stinginess: why buckets of popcorn can't match the overflowing ones in the pictures; by policy any popcorn that happens to get piled over a certain line is classified as 'wastage'. The onus in this trend of consumerist narrativisation is thus no longer on the customer wasting not and therefore wanting not; it's no longer even in their hands: the merchant now wastes not on them, telling them all the while to want it, to want *air*, to want *zero*, to want *free*, to want *less*, to want *loss*, to *want* not.

41. Relationship Breakdowns, Marx, and *Alice in Wonderland*

'You don't let me get to know you', 'You've changed!', 'I can't be myself around you'.

Such comments as these make familiar appearances in the language of relationships. They are all, on the surface, markedly different reasons for breaking up and ending a relationship. However, a bit of analysis shows that they all share a fundamental characteristic which shows us a problem at the heart of our conceptions of our loved ones, or rather, our rejected or passed-over would-be loved ones.

What all the comments share is a kind of doubling; if I say that you won't let me get to know you, I split you between the 'you' that I do know and the mysterious one that is being 'held back', as it were. Likewise, if I say that I can't be myself around you, we have much the same structure only in reverse; now it is 'me' who is split, into the one who behaves around you, and the somehow truer one who would be 'itself' if you allowed it to be.

What this shows us is our desire to believe in an internal identity or see ourselves as having a kind of presence 'within'. The temptation, in philosophical or theoretical terms, is to apply a theoretical assertion that this is false; really there is no internal identity, rather retorting to those who complain about us in these terms, 'how I appear to be is all I am'. This is not simple (for more see article 1 on email sign-offs, above), and is itself a valuable statement; it shows us how at the very moment of inadequacy, when our relationship is breaking down, we unconsciously turn back in language to an assertion of our own essential being as a way of 'dealing' with the problem.

However, what is perhaps more interesting is not stating the falsity of internal identity but analysing instead the effect or

construction of that internality. Internal identity may not be 'truly there', but its appearance and effects are nevertheless absolutely real. It is something that Karl Marx picks up on in his 'Theses on Feuerbach', where he writes: 'the human essence is no abstraction inherent in each single individual. In its reality it is the ensemble of social relations.'[95]

Here, Marx anticipates a later criticism of his concept of 'alienation'; that there is a problem with alienation because it implies a 'true' you from which to be alienated, much like our comments above, like 'I can't be myself around you.' Yet here, far from doing away with the idea, instead Marx acknowledges that such a 'human essence' is a social construction, and is interested in the 'reality' of that concept as a social construction.

Thinking about the production of identity as an effect is where one should turn to psychoanalysis. Mladen Dolar argues that 'one could say: *it is in the nature of identity to be mistaken as identity*. Or: the identity is but a gap between two appearances'.[96] Identity is a gap or absence, so that I am only established through difference from others (as Saussure says of language). But a mistake is made in that identity is taken for something present, something pre-existing, when in fact it is produced.

In this new way of framing the problem, rather than asking the question: 'who *really* are you?', or 'am I being *myself*?', one ought to ask: 'who are the people that I am not in order to make me who I am?' Indeed, Alice, in Wonderland, ponders the problem in exactly these terms:

["]I wonder if I've changed in the night. Let me think: *was* I the same when I got up this morning? [...] But if I'm not the same, the next question is 'Who in the world am I?' Ah, *that's* the great puzzle!" And she began thinking over all the children she knew that were of the same age as herself, to see if she could have been changed for any of them.

"I'm sure I'm not Ada," she said, "for her hair goes in such

long ringlets, and mine doesn't go in ringlets at all; and I'm sure I ca'n't be Mabel, for I know all sorts of things, and she, oh she knows such a very little![")][97]

Alice recognizes that identity is the gap between two appearances, that identity is established through difference – but not difference between pre-existing identities – rather, all that I am is the space between everyone that I have met, and indeed everyone that I have not met, every person or term in my discourse, from class-mates to celebrities to imaginary friends. The effect of essence or presence is a mistake, but it is a very real one.

As such, when our friends or lovers accuse us of having 'changed', what we are really dealing with is the fact that our position in their own symbolic chain has changed; that the position we occupied in relation to their sense of themselves has altered, forcing them to redefine themselves as the gap between the people they 'know', since that order of people they know has 'changed'.

Or when our lovers tell us that we didn't 'let them in' or 'let them get to know us', are we not dealing with another side of the same coin? It is not that they didn't get to 'know' us, but that they did get to know us, and what they found was different to what they expected, so that they faced the trauma that we did not occupy the position in their symbolic universe that they thought we did and that therefore they themselves were not what they thought they were in relation to us. At the moment you realize this, identity becomes completely unstable, subject to change with everyone you see or meet, and at this moment you attempt to re-inscribe stability by an anxious and failed reassertion of essence.

42. Mirosław Bałka's 'How It Is': *A Textual Analysis*

Jacques Derrida said of Samuel Beckett's works that they resist deconstructive analysis for the very reason that they are already deconstructive in themselves.[98] From 13 October 2009 to 5 April 2010 the title of Beckett's novel, *How It Is*, leant itself to Mirosław Bałka's Turbine Hall installation at the Tate Modern gallery, London, which consisted of 3,900 cubic metres (30 x 10 x 13 m) of dark space.[99] After experiencing the piece it becomes apparent that Derrida's summation of the literature of Beckett might come in useful in attempting to describe it as a work of art, but also, and perhaps more so, in trying to describe ourselves in relation to it.

When at the darkest point in the long room that is decorated entirely in black felt it becomes almost impossible to see those next to you and in front of you, even to see your own body or the hands you wave in front of your face to test yourself. You are suddenly alone with your mind and its incubi. In this sublime moment our deconstructed self becomes apparent; it is as the very darkness and nothingness that surrounds and encumbers it; and in its ontological realisation, whether causing a frantic dashing to and fro in thought, or recoil into a frozen heap psychologically, its inescapability is unavoidable. As Slavoj Žižek has put it, what we are here experiencing is perhaps that 'the "subject" is *nothing but* this dreaded "void"—in *horror vacui*, the subject simply fears himself, his constitutive void.'[100]

Figure 1 inadequately attempts to depict the view – like the pages of black in Lawrence Sterne's *Tristram Shandy* – that faces the individual at the entrance to Bałka's container of darkness; there are no defined edges to the all-encompassing abyss, no discernable lines where the corners of the structure meet; it is beyond geometry, a reified shapelessness. The experience is a visual meeting with the unseeable, the absence of light: colour-lessness.[101] In the deep, immediate blindness all communication is severed and what remains is the howling vacuity of complete acoustico-visual silence.

This is perhaps the reason that no one talks. There is the shuffle of people trying to find their way through the emptiness, but no conversation, save for a few exclamations of disorientation or terror. There is, then, only the collective of individual silences. The unsettling air of the exhibition becomes apparent; there is a perceived threat, it is the threat of the unknown, of darkness and of silence. Georges Bataille explains that 'since language is by definition the expression of civilised man, violence is silent,'[102] and whilst in Bałka's box of blackness the unnerving dumbness seems to become amplified: 'it is as if the silence itself has begun to speak', in Žižek's words.[103]

By this token the speech doesn't say anything. As with the classic Hitchcockian device used for creating suspense it is in what is not seen or heard that the terror of Bałka's 'How It Is' metastasises; the participant is left with their own imagination filling in the gaping gap, the absolute void of artistic spectacle and aesthetic possibility. The unconquerable black then is not only an absence of all light and therefore colour, but an absence (and in consequence, completeness) of anything and everything and is therefore creative of a creepy paradox; the oppressive darkness and quietness seemingly leave an existence outside of themselves unimaginable (there is only the solidness of their impenetrability) and yet the mind postulates innumerable circumstances that *could be happening* directly in front of the

participant's eyes, but which remain totally unperceivable …

The exterior of the monolithic sculpture is fully traversable; it can be seen from all angles, even from underneath, but it is a cold, clinical and calculated structure; with its ramp up into the towering steel box of darkness it is immediately reminiscent of the herding of animals into trucks before transportation to the abattoir, or more sinisterly, similarly of Jews into trucks before the slaughter of the Holocaust. But these staple associations of Bałka's work[104] become almost lost upon entering the piece, not to something deeper significantly, but to something more immediately direct.

When walking into the void one is hesitant of one's steps due to the awareness that others are going back and forth up ahead and due to the unawareness of possible hidden objects to stumble over, accidentally there, or intentionally. Indeed, a suspicion is thus created, of the otherness *of* the room and of the otherness *within* it. This self-reflectively posited notion of the possible evil lurking in the constant shadow of Bałka's piece is perhaps its uncomfortable apogee; a frenetic stasis of fear; moving forward into the unknown engenders the possibility of coming up against an undisclosed (and undisclosable) alterity; remaining still leaves the subject with the fear of their 'consti-tutive void.' (Of course, the viewer's volition is not violated, so at any point exiting is possible, and thus is an escape from what may seem to be 'the obscene infinity of evil.'[105])

'Evil is something which threatens to return for ever, a spectral dimension which magically survives its annihilation and continues to haunt us. This is why the victory of good over evil is the ability to die …'[106] In Žižek's definition of evil we encounter a double qualification in relation to Bałka's 'How It Is'; rather than dying, of course, leaving the installation is possible: discontinuing our direct physical-perceptual interrelation with the exhibition; however, its *hauntology* remains, that is, what it is (indeed, how it is) continues to be with us in every darkness,

silence and fear.

...And then you turn around. The exhibition cleverly changes when the end of the container is reached. There are bangs of people walking headlong into the black felt wall at the end; the knock though is fairly soft and insubstantial and becomes a relief that the trammelled descent into darkness is over. Upon turning, there is light at the end of the tunnel, but also in front of you are the silhouettes of scared people hesitantly walking into the abyss; the participant leaving the installation *is* now the very otherness of it, no longer a voided subject of/in the piece, but an undisclosed agent of alterity, regarding the fear of those that cannot see him/her (not in their faces but in their movements) and capable of increasing it by sneaking up *in front* of them: as a fellow participant told us at the end of the box looking out, 'that's my mum over there, coming in', she giggled and ran towards her mother's uncertain figure and gave her a fright. This playful jest rejoined a 'human' element to the preceding eerie vacuousness of the exhibition, and thus in going in and going out of 'How It Is' a deep truth of the dualistic/duopolistic nature of humankind seems to be revealed; that of the constitutive darkness within, and the light with which its counteraction is attempted.

43. Alain de Botton and the Narcissism of Melancholy

Since his first book in 1993, Alain de Botton has become the figurehead of what we might call 'popular philosophy,' with some of his books selling over two million copies each. In serious philosophical circles he may not be taken as seriously as he might hope, but the commonly heard defence is that de Botton's work bridges the gap between philosophy and the popular, making philosophy accessible to the masses. Of course, 'masses' here refers to a quite particular strand of bourgeois reader, but that discussion is for elsewhere. What we want to suggest here is that the appeal of Alain de Botton is found somewhere else entirely. De Botton's philosophy is popular because it indulges (and indeed takes part in the production of) the role that melancholy plays in contemporary society: as a form of narcissistic self-affirmation.

De Botton's work is openly about possible paths from misery and melancholy to happiness. He locates unhappiness as a universal and primary problem which we have to take as a kind of starting point. The first line of *How Proust Can Change Your Life* is 'there are few things humans are more dedicated to than unhappiness' and in the later *Status Anxiety,* he takes the line further, creating this concept of 'status anxiety' to describe a universal condition responsible for sorrow and misery – which the text then sets out to 'deal with.'[107]

De Botton's obsession is with causes. In the introduction to this text he states that 'status anxiety' is the *cause* of sorrow. In turn, 'status anxiety' is *caused* by 'recession, redundancy, promotions, retirement, envy' and many other things. One thing is caused by another, seemingly endlessly, and it comes as no surprise when one turns the page to find in large type: 'PART ONE: CAUSES'.

But there is no theory of causality here, only the endless deferral of one thing back to a cause elsewhere. What this does is complicate the issue; I have to see my sorrow as having a cause, and that cause as itself having a complex set of causes, some of which I know and some of which I don't. In short, I must think of my melancholy as a *symptom,* as something with a deep-rooted cause connected to me which I cannot make sense of. Thus, melancholy is not the breakdown of myself but rather a gesture of something like 'oh, I am so complicated I don't even under-stand myself' – who I *really* am is not challenged but affirmed; it is hidden in an impossible-to-decode string of causes and effects, but it is down there somewhere. Structurally it maps onto de Botton's own self-affirming narcissism. In *Status Anxiety* one finds a remarkable language, utterly incongruous with modern philosophy, asserting that ultimately there is such a thing as 'who we are deep down… who we are outside of our status.' For de Botton the contributing factors are primarily economic (redun-dancy, recession, etc.) and he may well acknowledge that our complex economic desires are the result of internalising standardised consumer desires, but he sees melancholy as the symptom of a disjoint between the way we are socially and who we are 'deep down.' Melancholy as symptom then, re-affirms this logic, asserting a complex inner 'me' which I affirm the existence of, even if I cannot make sense of it.

The identification of melancholy as being rooted in the relationship between internal and external (often uncontrollable) sources contributes to the idea that it's not 'your' fault, so you don't need to feel too bad, whilst actually reinforcing a narcis-sistic, inward-lookingness. Alain de Botton's books have a self-help dimension, appealing to those who are 'unhappy', but in fact they are ordering the reader *to be* unhappy, in order to create an appearance of an inner self at odds with the complex world, a relationship which then appears as the root of that unhappiness.

44. How did the Other get so Big? The Swallowing of Democracy by the Imaginary Order: *IDS, the big Public, and the Daily Mail*

We may be more familiar with the reference to the *'system'* – certainly in terms of *surveillance culture* – as *Big Brother*, or, indeed, even by the reduction of it to the figure of the *Nanny*, as in the mythologised notion of the 'Nanny State'. However, as Clement Attlee turns in his grave over our current state of affairs, it might well be worth putting our Lacanian thinking hats on and taking seriously conceptualising the *system* – or even, indeed, the *systematicity* of the system – in terms of the big Other.

The big Other is, in effect, that which we 'keep up appearances' for, and it is, therefore, bigger than all of us. It is the symbolic matrix that relies on us for its maintenance: our courtesy in everyday exchanges, our politeness in our email sign-offs (see the email article above), our following rules and abiding by the law, and our leading by example are all for – in Lacan's view – this radical other, the 'big Other'. But what happens when the symbolic big Other gets usurped by the imaginary order of ideology and its bloodthirsty peddlers and mongers?

It gets bigger. Bolstered by ideology-pushers the big Other enters an oral phase; i.e., it becomes able to swallow up huge swathes of 'popular opinion' by its annexed imaginary pole creating *such opinion*. It is in fact this opinion's ideologues who (re)create the big Other *in the image of the populace*. Let's take an example from the current dystopia of political events: the Iain Duncan Smith petition on change.org – challenging IDS to live on £53 a week, just as he is forcing benefits claimants in this country to do – has been dismissed by him as 'a complete stunt'; so much for petitions, democracy, and the old motto of 'by the people, for the people'. What Duncan Smith has done here, most

likely without realising, is made the Other bigger. Of course, his own self-inflation – at dismissing out of hand a petition now nearly 500,000 signatures strong – *should be* what is logically read here; but, instead, Duncan Smith has palmed the petition off as a stunt, and implies, in doing so, that its sensationalism can be verified by this ideological big Other. The linguistic audacity of the simple disclaimers 'of course…', or, 'naturally… it is a stunt', seem to be all that's needed now to pull off the trick.

It is in these very linguistic tricks (utilised in the hijacking of the symbolic order for imaginary ends) that we see such deferrals take place again and again. Another example – that might clarify and reinforce the point being made a bit more – can be found in the common trope of championing the great, yet completely imaginary and amorphous, '*Public*', so often referred to in the media: a bastion of (their) value(s), impervious to any deviation. This yoking of the big Other to a notion of the Public is a connivance put in place to reign the nation with a prevailing normativity: the most obvious example is in reportage of protests; a protest, by and large without fail in the media's eyes, puts this *Public* in some sort of danger. The fact that the previous week those protesting might have been this Public, and that the next week, when others are protesting, they will be again, does nothing to impede this *big Othering* of the *Public* (*image*). Now working under the supervision of this distorted big Other – i.e., the *big Public* – we have been made, by the image-conjurers, into that apparently *stable condition* which must be protected at all costs, and – and this is where the dystopic double-bind comes in – which must be protected at all costs *by us*.

It may be language games that determine the Symbolic Order, but when the peddlers of ideology and the implementers of a diversionary imaginary order learn their syntax the stakes are raised to drastically *anti-democratic* levels. The *Daily Mail* know it all too well, and display it in their current 'Vile Product of Welfare UK' front page (04/04/13): the way they utilise this

malleable language is in yoking a certifiable tragedy to the ends of their own agenda and selling it cheap: 'Welfare = Murderers'. It also displays something of the logic that Annie Edison employs as a prosecutor in the yam trial courtroom scene in *Community* ('Basic Lupine Urology', season 3, episode 17): *say it first, then withdraw it before it can even be objected to*; either way, the disparaging and damaging message is already 'out there'.

If ever an apology is proffered by the *Mail* for their headline (to that not unsubstantial percentage of welfare-users who don't commit atrocities), what will they care about the weight of words then? The damage, their goal, will already have been achieved by that intentionally heaviest of headlines. A fight – to reclaim (our) language from the Imaginary of IDS, the *big Public* and the *Daily Mail*, and to restore it to the Symbolic of the proper big Other, for which good manners and healthy functioning are everything – must be won if we're to survive into something other than Christopher Isherwood's prophesied 'Rubble Age'.[108]

45. Worbining (Word-combining)

These days sandwiching two words into one is everyday practice; perhaps the most common is 'chillax' (chill and relax) though 'granter' (great banter) also seems topical. One can pretty much say anything, even, 'that house is shit, it's a shouse', and get a laugh without even having to explain oneself, as long as it is clear which two words have been combined. We recently heard that this process can be referred to as 'worbining' (word-combining).[109]

Though it seems to be increasingly common, this is by no means a new thing. Freud notices several examples in his joke book (1905) including 'alcoholiday' (alcohol holiday), and, from Thomas De Quincey, 'anecdotage' (anecdote and dotage, something old people often fall into). And Freud tells a joke now famous in psychoanalysis to illustrate the point, in which a man meets the wealthy Baron Rothschild and, having expected him to be snooty and alienating, remarks, 'he treated me quite as his equal – quite famillionairely,' meaning: both familiarly, and 'as a millionaire would.'

Freud doesn't take the analysis all the way, but he does suggest that it might have to do with economizing – something is saved in shortening and sandwiching words which we derive pleasure from.

Yet, it seems that worbining is funny not because it is able to contain two words and mean both ('I am chilling AND relaxing') and also not because it means neither one of the two words ('I am chillaxing, not chilling OR relaxing'). Rather, worbining is funny because it erases the gap between two words – the thing which usually keeps them apart as meaning two different things. And yet, the meaning is there nonetheless, almost but not completely undistinguishable from the original. A third word is created, and it operates just like the two words it combines. The message of

worbining is: 'each word doesn't relate to a different thing which exists anyway, but it creates them': I can now *chillax*, where before I could only chill and/or relax.

46. 'One Word: Plastics' – A Parable of Discord in *The Graduate*

We should perhaps read the famous scene at the beginning of *The Graduate*, where Mr McGuire takes the just-graduated Ben aside and gives him the 'one word' of advice, '*plastics*', in which 'there's a great future', as a parable of discord; generational, and also, by extension, class-economic. The good news of *plastics* is met with by Ben in tones that seemingly hover somewhere between a nonplussed despondency and an unfazed apathy – all of which is realised by the young Dustin Hoffman's brilliantly-(under)stated blanket blankness – but there might be more to it than just these epithets. The trope of discord – present from the off and throughout the film as a whole – is emphasised slightly earlier, however, when Ben is asked by the lady guests what's he going to do now. 'Go upstairs for a minute' is his reply, and then they insist that they were rather enquiring after his future, his life in general. 'Well, that's a little hard to say...' '*Plastics*' is what Mr McGuire is able to say to this vague future, and he makes it there and then a done 'deal'.

Roland Barthes, in his analysis, says of plastic that, 'as its everyday name indicates, it is ubiquity made visible'.[110] But in this abstract sense, how visible has it become to Ben? Not at all. The problem is, of course, that plastics cannot be visible to him (at this point, and from this pithy prophesy) as a future; it couldn't become so to anyone without at least Mr McGuire's business foresight; a foresight presumably informed by the hindsight that goes with years of related market knowledge. Less so is it in any way ubiquitous as a future, as the exclusivity of market forces and business morality (as opposed to the overused and often oxymoronic term 'business ethics') tends to insist. Mr McGuire's ostensibly good-natured but ultimately disinvested act may therefore be comparable to the suggestion made to a student

of the Arts and Humanities, in financial straits, that they should 'just become an entrepreneur'; of course, 'real life' isn't another episode of *Dragons' Den*...

Ben, however, is of course well set-up and a great future, socio-economically, is almost guaranteed; nonetheless, he's willing to gamble it all – of course, as it's a movie, in the name of *love* – and that's why his blanket blankness to all else becomes so charming. It's not, then, the apathy of youth that we're seeing – or whatever else the more conservative of the older generation might like to tout it as – but, ultimately, rather *the appropriate response* to the pervasive situation of disconnect, of discord, that he (as well as Mrs Robinson) is aware of throughout the banality of the day-to-day.

So, what is ours in our day-to-day? One aspect of our discord arises in austerity; when we are told that by doing up our belts we can somehow loosen the tightness of the times we can only really meet this coercion with the bewilderment that Ben meets Mr McGuire's with; when we realise that our inheritance is debt, and that we are somehow made to feel responsible – and to be held accountable – for this, we should radically try to shake off all these other people's designs for us, just as Ben manages to do for himself, and for his and Elaine's – albeit undecided – future; as it is the *future* itself that faces us all.

Endnotes

1. http://everydayanalysis.com/

2. Gilles Deleuze and Félix Guattari, *A Thousand Plateaus: Capitalism and Schizophrenia, Vol. 2*, trans. by Brian Massumi (London: Continuum, 2004) p.3.

3. The story of Forster and Eliot's exchange can also be found in P. N. Furbank, 'Forster, Eliot, and the Literary Life', *Twentieth Century Literature*, 31st ser., 2/3 (1985) 170-179 (p.170).

4. Roland Barthes, *Mythologies*, trans. by Annette Lavers (London: Vintage Classics, 2009).

5. To recall the now *ex*-Continuum Books' *Impacts* series' slogan.

6. Jean-Claude Milner, *L'Œuvre claire: Lacan, la science, la philosophie* (Paris: Éditions du Seuil, 1995) p.8. Translation our own.

7. As it's called in the Zero Books manifesto, which can be found at the back of any of their published works.

8. https://twitter.com/RichardDawkins/statuses/32484846610 4832000

9. Barthes, 'Blind and Dumb Criticism', in *Mythologies*, pp.27-29.

10. Indeed, Foucault gets at what we might call the *ethical* crux of this matter – concerning where the deemability of under-standability is proffered from, and where ideas of authority and authorship originate – with these penetrating questions: 'Who is speaking? Who, among the totality of speaking individuals, is accorded the right to use this sort of language (*langage*)? Who is qualified to do so? Who derives from it his own special quality, his prestige, and from whom, in return, does he receive if not the assurance, at least the presumption that what he says is true? What is the status of individuals

who – alone – have the right, sanctioned by law or tradition, juridically defined or spontaneously accepted, to proffer such a discourse?' – Michel Foucault, *The Archaeology of Knowledge*, trans. by A. M. Sheridan Smith (Abingdon: Routledge Classics, 2002) p.55.

11. Slavoj Žižek, *Less than Nothing: Hegel and the Shadow of Dialectical Materialism* (London: Verso, 2012) p.395.

12. Matthew J. X. Malady, 'You Say "Best." I Say No.', http://www.slate.com/articles/life/culturebox/2013/03/email _signoffs_end_them_forever_best_yours_regards_they_re_ all_terrible.html

13. Katie Davies, 'Is being polite in emails a waste of time? Calls to END perfunctory sign offs such as 'regards'', http://www.dailymail.co.uk/news/article-2292988/Is-time-say-Regards-email-sign-offs-Debate-rages-need-polite-farewell-online-exchanges.html

14. Robert Pfaller, 'Disinhibition, Subjectivity and Pride. Or: Guess Who Is Looking?', in *In Medias Res: Peter Sloterdijk's Spherological Poetics of Being*, ed. Willem Schinkel and Lisbeth Noodegraaf-Eelens (Amsterdam: Amsterdam University Press, 2011) p.74.

15. Eve Arnold, quoted in Richard Brown, 'Marilyn Monroe Reading *Ulysses*: Goddess or Post-Cultural Cyborg?', in *Joyce and Popular Culture*, ed. by R. B. Kershner (Gainesville: University Press of Florida, 1996) p.174.

16. Walter Benjamin, 'Little History of Photography', trans. by Edmund Jephcott and Kingsley Shorter, in *The Work of Art in the Age of its Technological Reproducibility and Other Writings on Media*, ed. by Michael W. Jennings and others (Cambridge, MA: The Belknap Press of Harvard University Press, 2008) pp.276-278.

17. Declan Kiberd, *Ulysses and Us: The Art of Everyday Living* (London: Faber and Faber, 2009) p.70. He is quoting from Walter Benjamin, *The Origin of German Tragic Drama*, trans.

by John Osborne (London: Verso, 1998) p.44.

18. See Jacques Lacan, *The Seminar of Jacques Lacan, Book X: Anxiety*, trans. by Cormac Gallagher (London: Karnac, unofficial translation) session VI, p.10.

19. Roger Caillois, 'Paris, mythe moderne', quoted in Walter Benjamin, *The Arcades Project*, ed. by Rolf Tiedemann, trans. by Howard Eiland and Kevin McLaughlin (Cambridge, MA: The Belknap Press of Harvard University Press, 1999) p.199.

20. Sigmund Freud, *The Interpretation of Dreams*, in *The Standard Edition of the Complete Psychological Works of Sigmund Freud, Volume V (1900-1901): The Interpretation of Dreams (Second Part) and On Dreams*, ed. by James Strachey, with Anna Freud, assisted by Alix Strachey and Alan Tyson, 24 vols (London: Vintage, 2001) V, p.525.

21. Roland Barthes, *Camera Lucida: Reflections on Photography*, trans. Richard Howard (New York: Farrar, Straus and Giroux, 1981) p.87.

22. Walter Benjamin, 'Eduard Fuchs, Collector and Historian', trans. by Howard Eiland and Michael W. Jennings, in *The Work of Art in the Age of its Technological Reproducibility and Other Writings on Media*, p.127.

23. Slavoj Žižek, *Looking Awry: An Introduction to Jacques Lacan through Popular Culture* (Cambridge, MA: October Books, 1991) p.137.

24. ibid.

25. See Jacques Derrida, '*Sauf le nom (Post-Scriptum)*', in *On the Name*, ed. by Thomas Dutoit, trans. by David Wood, John P. Leavey Jr., and Ian McLeod (Stanford: Stanford University Press, 1995) p.25.

26. Jacques Derrida, *The Politics of Friendship*, trans. by George Collins (London: Verso Radical Thinkers, 2005) p.283. The discussion of and quotations from *Zarathustra* are found here also.

27. Richard Appignanesi and Chris Garratt, with Ziauddin

Sardar and Patrick Curry, *Introducing Postmodernism* (Cambridge: Icon Books Ltd., 2007) p.136.

28. Žižek, *Less than Nothing*, p.613.

29. See Jacques-Alain Miller, 'Suture (Elements of the Logic of the Signifier)', trans. by Jacqueline Rose, in *Concept and Form: Volume 1, Key Texts from the* Cahiers pour l'Analyse, ed. by Peter Hallward and Knox Peden, 2 vols (London: Verso, 2012) I, pp.91-101.

30. Barthes, 'The Great Family of Man', in *Mythologies*, p.123.

31. Shahidul Alam, quoted in TIME Photo Department, 'A Final Embrace: The Most Haunting Photograph from Bangladesh', http://lightbox.time.com/2013/05/08/a-final-embrace-the-most-haunting-photograph-from-bangladesh/#ixzz2UdS4wVoO

32. Talisma Akhter, quoted in James Estrin, 'Fighting Hopelessness Amid Ashes', http://lens.blogs.nytimes.com /2012/11/29/fighting-hopelessness-amid-ashes/

33. Barthes, 'The Great Family of Man', in *Mythologies*, p.121.

34. ibid. p.123.

35. Akhter, in Estrin, 'Fighting Hopelessness Amid Ashes'.

36. Barthes, 'The Great Family of Man', in *Mythologies*, p.122.

37. ibid. p.124.

38. See Alenka Zupančič, *The Odd One In: On Comedy* (Cambridge, MA: MIT Press, 2008) pp.33-34

39. See Jacques Lacan, *Le seminaire, Livre XXIII: Le sinthome*, texte établi par Jacques-Alain Miller (Paris: Éditions du Seuil, 2005), p.123, for example.

40. Recounted in Jacques Mercanton, 'The Hours of James Joyce', trans. by Lloyd C. Parks, in *Portraits of the Artist in Exile: Recollections of James Joyce by Europeans*, ed. by Willard Potts (San Diego: Harcourt Brace Jovanovich, 1986) p.213.

41. See the chapter 'Freud's Masterplot: A Model for Narrative', in Peter Brooks, *Reading for the Plot: Design and Intention in Narrative* (Cambridge, MA: Harvard University Press, 1992)

pp.90-113.

42. https://twitter.com/RichardDawkins/status/30026454174
3374337

43. Friedrich Nietzsche, *Twilight of the Idols*, trans. by Duncan Large (Oxford: Oxford World Classics, 1998) III.6, p.19.

44. https://twitter.com/RichardDawkins/status/32480255151 6106752

45. Nietzsche, *Twilight of the Idols*, III.5, p.18.

46. ibid. III.5, p.19.

47. Slavoj Žižek, *In Defense of Lost Causes* (London: Verso, 2008) p.374.

48. Jacques Derrida, *Specters of Marx: The State of the Debt, The Work of Mourning, and The New International*, trans. by Peggy Kamuf (Abingdon: Routledge Classics, 2006) p.245, note 39.

49. See his obituary of Richard Nixon: Hunter S. Thompson, 'He Was a Crook', in *Rolling Stone*, June 16, 1994.

50. Derrida, *Specters of Marx*, p.xviii.

51. ibid. p.10.

52. See also Paul Gilroy's Twitter playlist, *The People Remember*, featuring: Lion Youth – 'Three Million on the Dole', Big Youth – 'Political Confusion', Lion Youth – 'Rat & Cut Bottle', The Enemy Within – 'Strike', Light of the World – 'Boys in Blue', and Reggae Regular – 'Violence in the Streets'. Margaret Thatcher's death was originally reported online by the BBC with a typo which attributed the cause to a 'strike' rather than a 'stroke'.

53. Walter Benjamin, 'Some Motifs in Baudelaire', in *Baudelaire: A Lyric Poet in the Era of High Capitalism*, trans. by Harry Zohn (London: Verso, 1997) p.113.

54. Jean-Paul Sartre, *Saint Genet: Actor and Martyr*, trans. by Bernard Frechtman (Minneapolis: University of Minnesota Press, 2012) p.503.

55. ibid. p.350.

56. Walter Benjamin, 'The Work of Art in the Age of its

Technological Reproducibility: Second Version', trans. by Edmund Jephcott and Harry Zohn, in *The Work of Art in the Age of its Technological Reproducibility and Other Writings on Media*, p.42.

57. Jonathan Freedland, 'George Osborne: master of the game of divisive politics', http://www.theguardian.com/commentisfree/2013/jun/26/george-osborne

58. Deleuze and Guattari, *A Thousand Plateaus*, p.465.

59. This idea is traced from Thomas Hobbes. See Thomas Hobbes, *Leviathan* (Indiana: Hackett Publishing, 1994) p.34. See also Simon Critchley, *On Humour* (London: Routledge, 2002) p.11.

60. G. W. F. Hegel, *Hegel's Aesthetics: Lectures on Fine Art*, trans. by T. M. Knox, 2 vols (Oxford: Oxford University Press, 1975) II, p.728.

61. Georges Bataille, 'Mouth', in *Visions of Excess: Selected Writings, 1927-1939*, trans by Allan Stoekl, with Carl R. Lovitt and Donald M. Leslie, Jr. (Manchester: Manchester University Press, 1985) p.59.

62. For more on this see Oxana Timofeeva, *History of Animals: An Essay on Negativity, Immanence and Freedom* (Maastricht: Jan van Eyck Aademie, 2012).

63. Michael Gove, 'We must return to traditional teaching values', http://www.dailymail.co.uk/debate/article-20661 41/MICHAEL-GOVES-SPEECH-How-reform-patronising-schools-stifle-ambition.html

64. Damian Thompson, 'Wagner is more important than the wretched Lib Dems', http://blogs.telegraph.co.uk/news/ damianthompson/100182934/wagner-is-more-important-than-the-wretched-lib-dems/

65. Charles Baudelaire, 'Richard Wagner and *Tannhäuser* in Paris', in *Selected Writings on Art and Artists*, trans. by P. E. Charvet (Cambridge: Cambridge University Press, 1981) p.328.

66. Kate Connolly, 'German Nazi-themed opera cancelled after deluge of complaints', http://www.guardian.co.uk/world/2013/may/09/german-nazi-opera-cancelled-wagner-tannhauser

67. ibid.

68. Theodor Adorno, *In Search of Wagner*, trans. by Rodney Livingstone (London: Verso, 2005) p.4.

69. ibid.

70. Slavoj Žižek, 'Foreword: Why is Wagner Worth Saving?', in ibid. p.viii.

71. Thomas Mann, *The Magic Mountain*, trans. by H. T. Lowe-Porter (London: Vintage, 1999) p.219.

72. Friedrich Nietzsche, *Thus Spoke Zarathustra*, trans. by R. J. Hollingdale (London: Penguin, 2003) p.236.

73. John McInally, quoted in Owen Jones, *Chavs: The Demonization of the Working Class* (London: Verso, 2011) p.127.

74. Gemma Moss, 'Panopticism Now', http://adornomental.tumblr.com/post/43242693560/panopticism-now, now also featured at everydayanalysis.com.

75. Jones, *Chavs*, p.127.

76. Jean Baudrillard, *The Transparency of Evil: Essays on Extreme Phenomena*, trans. by James Benedict (London: Verso, 1993) p.106.

77. Appignanesi et al, *Introducing Postmodernism*, p.122.

78. Baudrillard, *The Transparency of Evil*, p.105.

79. Theodor W. Adorno, 'Cultural Criticism and Society', trans. by Samuel Weber and Shierry Weber Nicholsen, in *Can One Live After Auschwitz? A Philosophical Reader*, ed. by Rolf Tiedemann (Stanford: Stanford University Press, 2003) p.162.

80. Eva Schloss, quoted in Neil Tweedie, "Living in the shadow of Anne Frank was a burden", http://www.telegraph.co.uk/history/world-war-two/9995358/Living-in-the-shadow-of-

Anne-Frank-was-a-burden.html

81. Katie Docherty, 'Anne Frank WOULD have been a Belieber insists stepsister', http://www.thesun.co.uk/sol/homepa ge/news/4891756/anne-frank-would-have-probably-been-belieber.html

82. Quoted in Lucy Wood, 'Will.I.Am Defends Justin Bieber's Anne Frank Comment: "He Could Get Sex and Drugs but he Chose a Museum"', http://www.sugarscape.com/main-topics/lads/856403/william-defends-justin-bieber's-anne-frank-comment-"he-could-get-sex-and-dru

83. Catherine Belsey, *The Subject of Tragedy: Identity and Difference in Renaissance Drama* (London: Routledge, 1985) p.1.

84. George Antheil, 'Abstraction and Time in Music' in *MANIFESTO! A Century of isms*, ed. by Mary Ann Caws (Nebraska: University of Nebraska Press, 2001) pp.651-652.

85. For more on this concept, see its use in the above article, 'Why Justin Bieber Should Listen to Neutral Milk Hotel'.

86. See, for example, Walter Benjamin, 'Theory of Distraction', trans. by Howard Eiland, in *The Work of Art in the Age of its Technological Reproducibility and Other Writings on Media*, pp.56-57.

87. Judith Butler, *Gender Trouble: Feminism and the Subversion of Identity* (Abingdon: Routledge Classics, 2006) p.29.

88. See ibid. p.30.

89. http://www.solutionsworld.co.uk/Personal-Massager/Pro duct_20054_-1_102287_11552

90. Georges Bataille, *Eroticism: Death and Sensuality*, trans. by Mary Dalwood (London: Marion Boyars, 2006) p.31.

91. Sigmund Freud, "'Civilized' Sexual Morality', in *Complete Psychological Works, Volume IX (1906-1908)*, p.187.

92. Bataille, *Eroticism*, p.252.

93. Jacques Lacan, *The Seminar of Jacques Lacan, Book VII: The Ethics of Psychoanalysis, 1959-1960*, trans. by Dennis Porter

(Abingdon: Routledge Classics, 2008) p.17.

94. ibid. pp.17-18.

95. Karl Marx, 'Theses on Feuerbach', in Karl Marx and Frederick Engels, *Collected Works*, 50 vols (Moscow: Progress Publishers, 2005) V, p.4.

96. Mladen Dolar, 'Comedy and its Double' in *Schluss mit der Komodie!: Zue schleichenden Vorherrschaft des Tragischen in unserer Kultur/Stop that Comedy!: On the Subtle Hegemony of the Tragic in Our Culture*, ed. by Robert Pfaller (Wien: Slonderzahl, 2005) p.184.

97. Lewis Carroll, *Alice's Adventures in Wonderland*, in *Alice's Adventures in Wonderland* and *Through the Looking-Glass*, ed. by Hugh Haughton (London: Penguin Classics, 1998) pp.17-18.

98. See Derrida's interview with Derek Attridge: '*D.A.* Is there a sense in which Beckett's writing is already so "deconstructive," or "self-deconstructive," that there is not much left to do?

 J.D. No doubt that's true. [...] The composition, the rhetoric, the construction and the rhythm of his works, even the ones that seem the most "decomposed," that's what "remains" finally the most "interesting", that's the work, that's the signature'. – Derek Attridge and Jacques Derrida, '"This Strange Institution Called Literature": An Interview with Jacques Derrida', trans. by Geoffrey Bennington and Rachel Bowlby, in *Acts of Literature*, ed. by Derek Attridge (London: Routledge, 1992) p.61.

99. Paulo Herkenhoff, 'The Illuminating Darkness of *How It Is*', in Mirosław Bałka, *How It Is*, ed. by Helen Sainsbury (London: Tate Publishing, 2009) p.50.

100. Slavoj Žižek, *Enjoy Your Symptom! Jacques Lacan In Hollywood and Out* (Abingdon: Routledge, 2008) p.158.

101. As is the definition of 'black': 'the proper word for a certain quality practically classed among colours, but consisting

optically in the total absence of colour, due to the absence or total absorption of light, as its opposite *white* arises from the reflection of all the rays of light' – *OED*.

102. Bataille, *Eroticism*, p.186.

103. Žižek, *Enjoy Your Symptom!*, p.27, note 6.

104. 'Inextricably entwined with the place and time of Bałka's corporeal form is the place, Poland, and the time since the Second World War and the Holocaust, that lengthy, in some way still ongoing 'postwar' period." – Julian Heynen, 'That's How It Is', in Bałka *How It Is*, p.27.

105. Slavoj Žižek, *Violence: Six Sideways Reflections* (London: Profile Books Ltd., 2009) p.56.

106. ibid.

107. Alain de Botton, *How Proust Can Change Your Life* (New York: Vintage, 1998) p.3. See also Alain de Botton, *Status Anxiety* (New York: Vintage, 2004).

108. See Christopher Isherwood, *A Single Man* (London: Vintage Classics, 2010) p.68.

109. Credit for the coining of this worbined word goes to Cina Bolton.

110. Barthes, 'Plastic', in *Mythologies*, p.117.

zero
books

Contemporary culture has eliminated both the concept of the public and the figure of the intellectual. Former public spaces – both physical and cultural – are now either derelict or colonized by advertising. A cretinous anti-intellectualism presides, cheerled by expensively educated hacks in the pay of multinational corporations who reassure their bored readers that there is no need to rouse themselves from their interpassive stupor. The informal censorship internalized and propagated by the cultural workers of late capitalism generates a banal conformity that the propaganda chiefs of Stalinism could only ever have dreamt of imposing. Zer0 Books knows that another kind of discourse – intellectual without being academic, popular without being populist – is not only possible: it is already flourishing, in the regions beyond the striplit malls of so-called mass media and the neurotically bureaucratic halls of the academy. Zer0 is committed to the idea of publishing as a making public of the intellectual. It is convinced that in the unthinking, blandly consensual culture in which we live, critical and engaged theoretical reflection is more important than ever before.